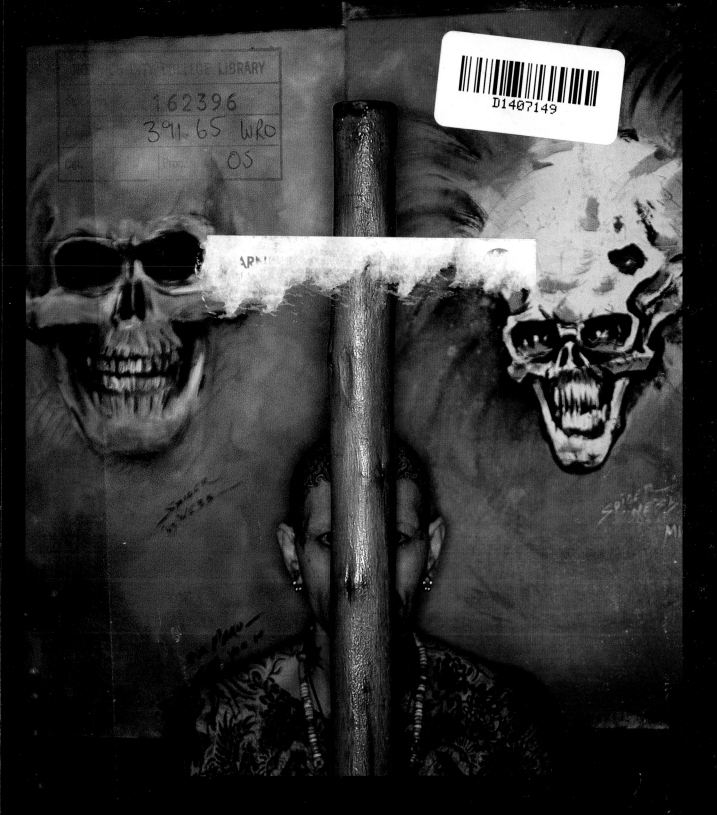

COLLEGE LIBRARY
162396
391.65 WRO
OS

D1407149

SKIN SHOWS IV

CHRIS WROBLEWSKI

Virgin

162 396

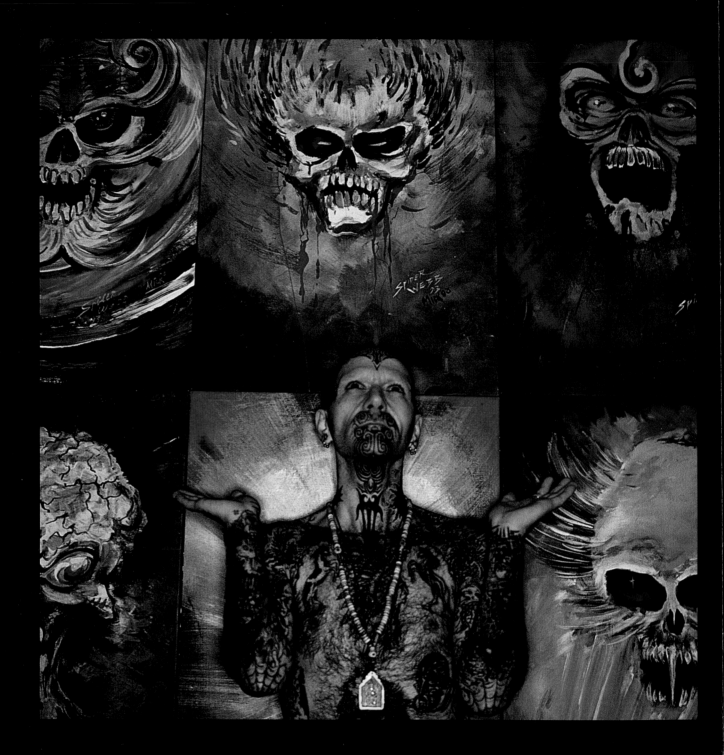

First published in 1995 by Virgin Books, an imprint of Virgin Publishing Ltd, 332 Ladbroke Grove, London W10 5AH.

Copyright © Chris Wroblewski 1995

The right of Chris Wroblewski to be identified as the author of this work has been asserted by him in accordance with the copyright designs and patents act 1988.

This book is sold subject to the condition that is shall not, by way of trade or otherwise, be lent, resold, hired out or otherwise circulated without the publisher's prior written consent in any form of binding or cover other that that in which it is published and without a similar condition being imposed upon the subsequent purchaser.

A catalogue record for this book is available from the British Library.

ISBN 0-86369-948-0

Designed by Omaid Hiwaizi, HHM..., London.

alt.intro.text by Steve Beard, author of Voodoo Ray, a Cyberphunk SF Novel set in a future London.

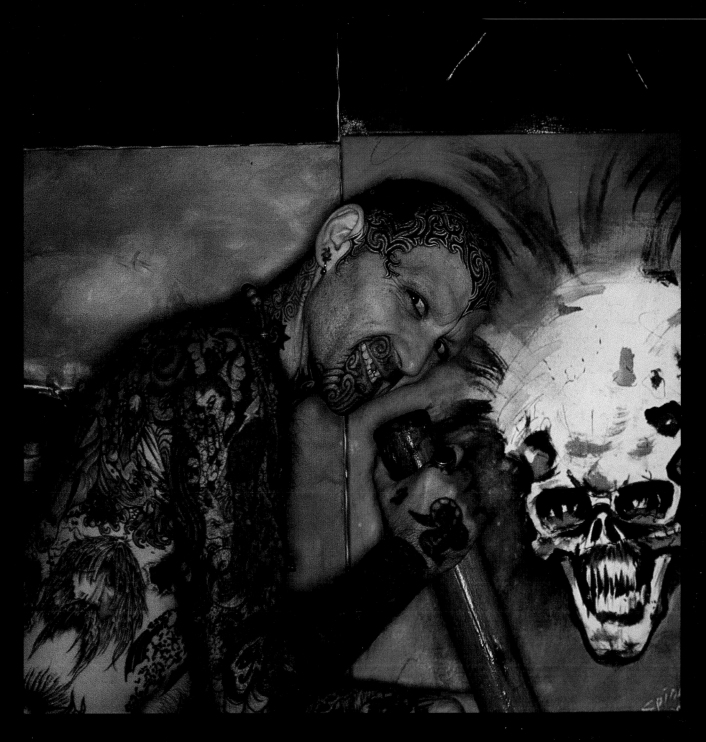

Shukren

Guy Lloyd and Virgin Books, Omaid Hiwaizi, Mysterious Willy, Jimmy Wong, Billy, Chak, Hans Lim, Graham Cavanagh, Alex Binnie, Curly, Steve Droog Tavita and Chloe, Olivier and Tiki Village, Pote, Jesse, Riley, Maurizio, Rinto, Clairey, Roy Proudlove, Luca, Hamish, Tanya, Marco Firinu, Mr Byron, Hung, Marco Leoni, Jurate, Jonathan Topps, Fuji, U.K., Eva, Glynn, The Lab, Olympus Optical, Germany and U.K, Diego, Suemalo, Micky, Spider Webb, Jordi, Macou, Mr Loubet, Tattoo Clothing, Miss Roxy, Felix, Loretta, Filip, Titine, Erik Reime, Steve Beard and Heide.

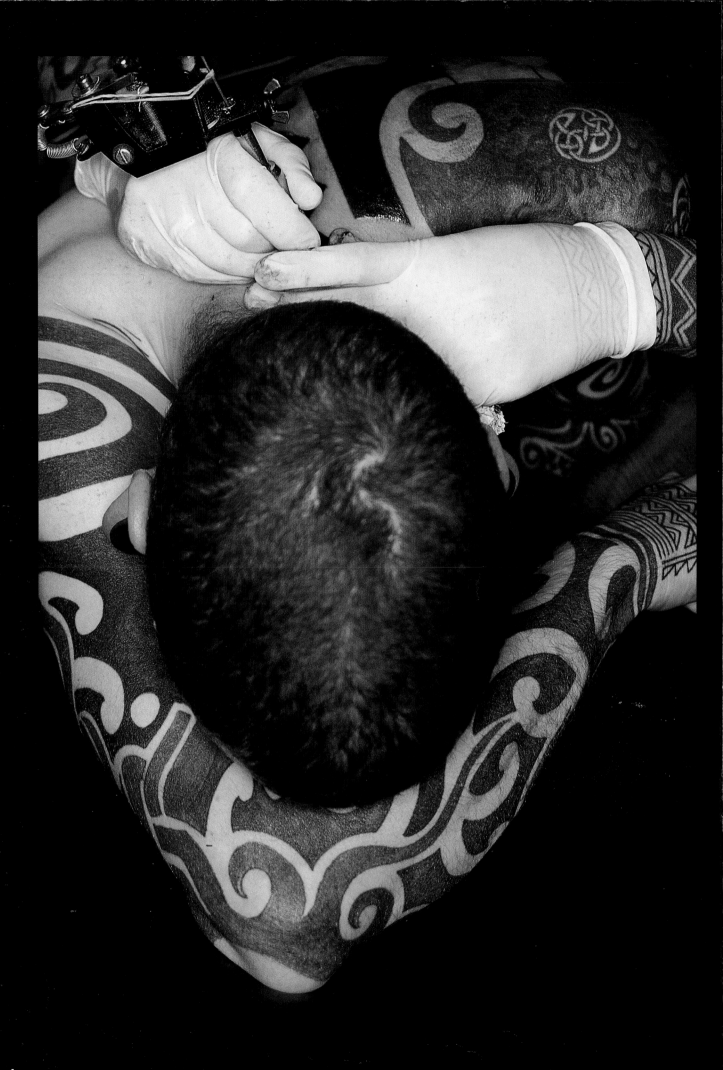

1 "Tattoo". From the Tahitian, **tatau** – meaning "to mark". Possibly onomatopoeiac, referring to the beating of two wooden sticks – one to indent the skin and inject the pigment, the other to apply direction and force. Compare the use of the drums in Haitian **voudon** ritual, where the "break" or **casse** in the sacred percussion rhythms releases the invoked **loa** or spirit deity into the body of the dancer. Speculation: that early tattooing belonged to a complex body of shamanic tech which may have included dancing, music and drugs among its vectors.

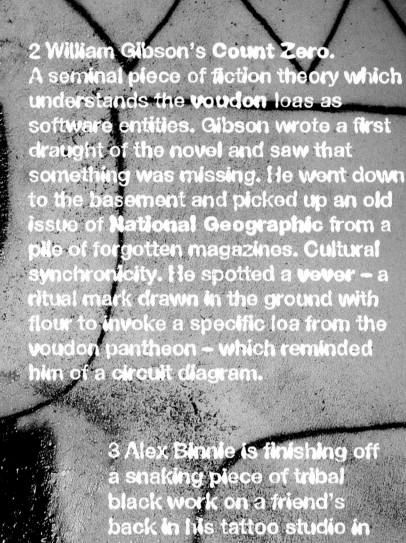

2 William Gibson's **Count Zero**.
A seminal piece of fiction theory which understands the **voudon** loas as software entities. Gibson wrote a first draught of the novel and saw that something was missing. He went down to the basement and picked up an old issue of **National Geographic** from a pile of forgotten magazines. Cultural synchronicity. He spotted a **vever** – a ritual mark drawn in the ground with flour to invoke a specific loa from the voudon pantheon – which reminded him of a circuit diagram.

3 Alex Binnie is finishing off a snaking piece of tribal black work on a friend's back in his tattoo studio in North London. He wears white surgical gloves and holds an electric tattoooing needle in his right hand as if it were a surgical scalpel or a rotary pen. After stretching his friend's skin taut with his free hand to produce a good surface for inscription, he wipes excess blood from his nib with a wad of Kleenex, dips it onto a pot of suspended pigment and then tattoos a clean black line into the quadrant of flesh revealed before him. He works quickly.

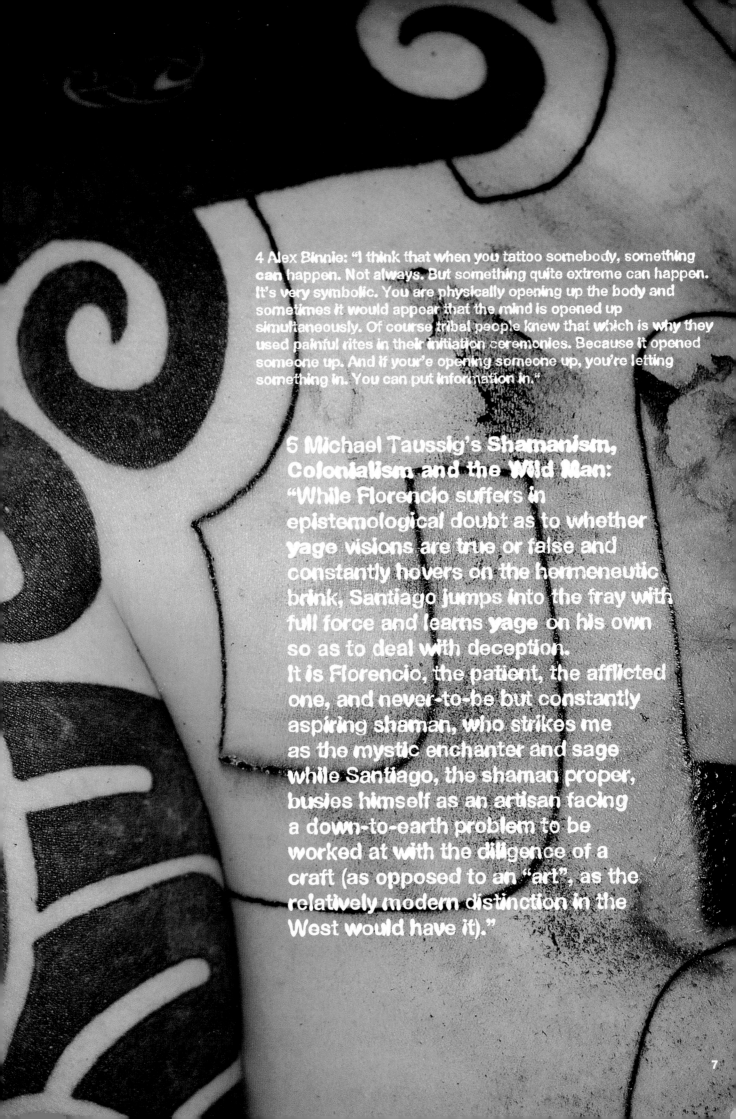

4 Alex Binnie: "I think that when you tattoo somebody, something can happen. Not always. But something quite extreme can happen. It's very symbolic. You are physically opening up the body and sometimes it would appear that the mind is opened up simultaneously. Of course tribal people knew that which is why they used painful rites in their initiation ceremonies. Because it opened someone up. And if your'e opening someone up, you're letting something in. You can put information in."

5 Michael Taussig's **Shamanism, Colonialism** and the **Wild Man:** "While Florencio suffers in epistemological doubt as to whether **yage** visions are true or false and constantly hovers on the hermeneutic brink, Santiago jumps into the fray with full force and learns **yage** on his own so as to deal with deception.
It is Florencio, the patient, the afflicted one, and never-to-be but constantly aspiring shaman, who strikes me as the mystic enchanter and sage while Santiago, the shaman proper, busies himself as an artisan facing a down-to-earth problem to be worked at with the diligence of a craft (as opposed to an "art", as the relatively modern distinction in the West would have it)."

6 Tattooing as the imprinting of **vevers** on human skin. The rewiring of the human body so that it is receptive to the call of the loas. J G Ballard on VR: "What we see around us now is a virtual reality system. The external reality each of us sees is a construct created by the central nervous system." The VR datasuit considered as a skin prosthetic. Circuit diagrams imprinted on an electronic screen. But who needs to wait for Silicon Valley to virtualize the tattoo?

7 o(rphan) d(rift>): "Cybersex depends critically on datasuits, evaporating into the nanominiaturized molecular machinery of an artificial skin, until the sockets go in, shadowed by teleneurocontrol fields, and things begin to get really weird. The capital exhibition comes to its positive end in a skinning display." Compare organ harvesting. Cadavers cannibalized by the medical industry for spare parts. Why not donate your skin instead to an art gallery? On display in the Amsterdam Tattoo Museum: a piece of tattooed forearm skin from a whaler in the 1850s.

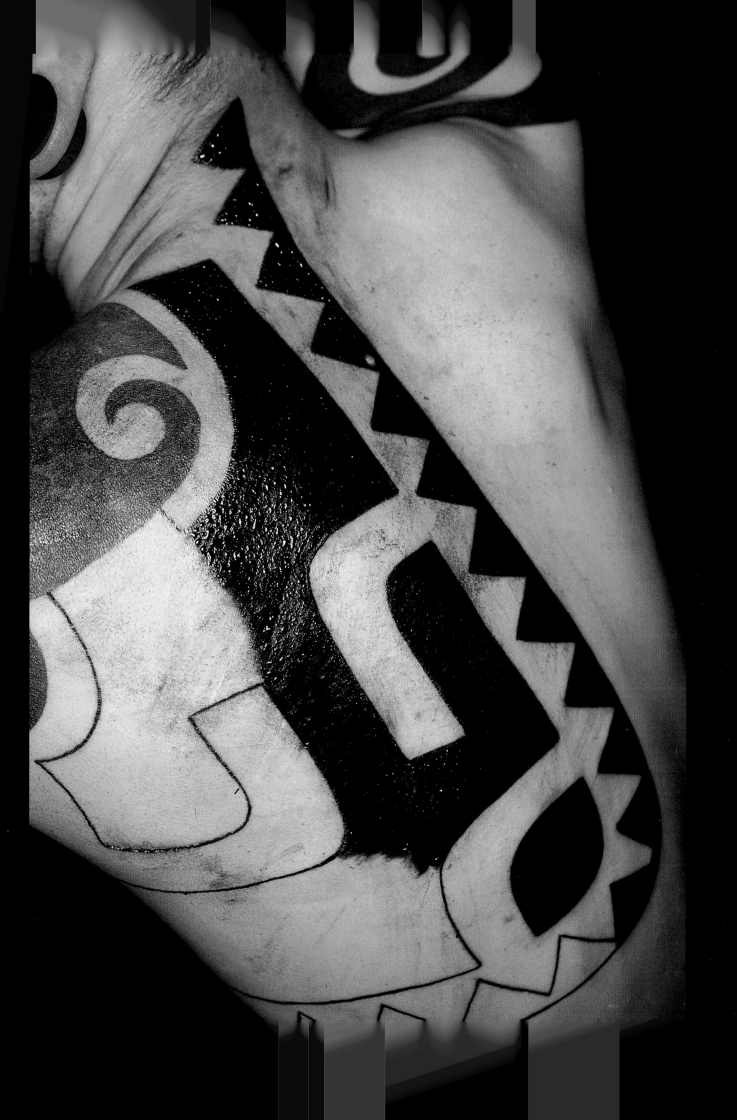

8 NYC art dealers sniffing around the tattoo scene. Aesthetic recommodification. The same thing that happened to the graffiti scene 10 years ago. Sign systems transferred from subway carriages to SoHo lofts. Now available on the Internet. Tony Kaye exhibits a homeless man in Saatchi's London gallery. Return of the Illustrated Man. Compare Chris Wroblewski's photographs. These are not portraits. He's only interested in curating the tattooed mark. Forget human subjectivity.

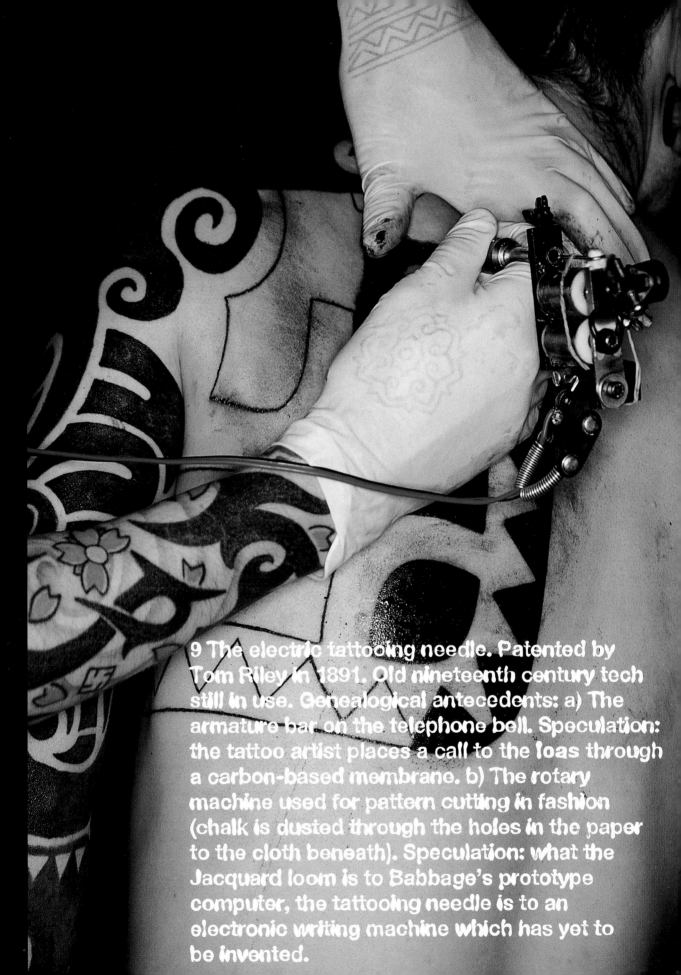

9 The electric tattooing needle. Patented by Tom Riley in 1891. Old nineteenth century tech still in use. Genealogical antecedents: a) The armature bar on the telephone bell. Speculation: the tattoo artist places a call to the loas through a carbon-based membrane. b) The rotary machine used for pattern cutting in fashion (chalk is dusted through the holes in the paper to the cloth beneath). Speculation: what the Jacquard loom is to Babbage's prototype computer, the tattooing needle is to an electronic writing machine which has yet to be invented.

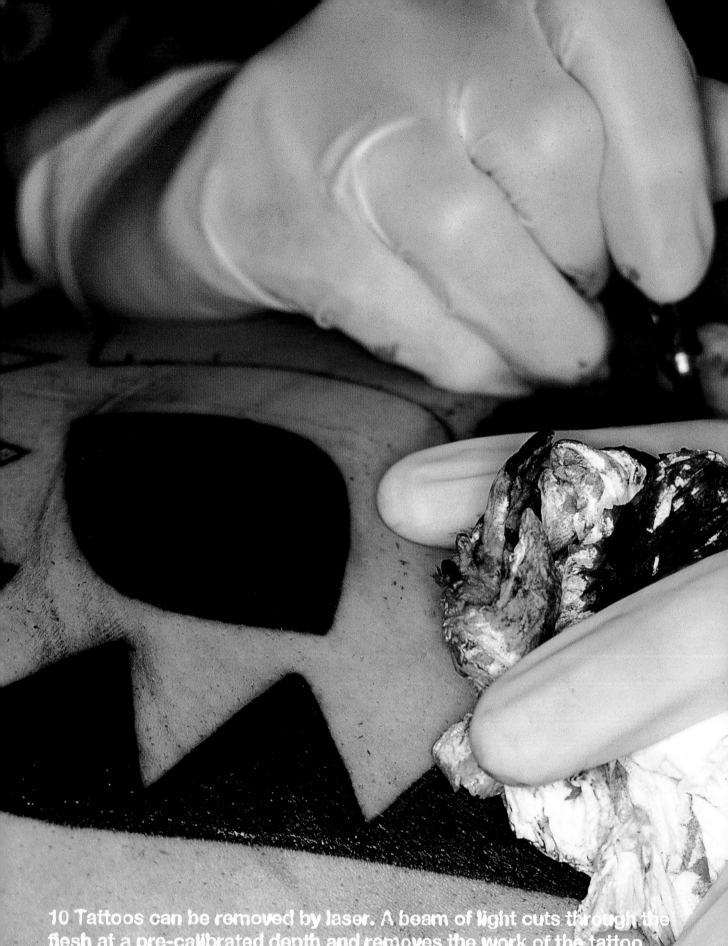

10 Tattoos can be removed by laser. A beam of light cuts through the flesh at a pre-calibrated depth and removes the work of the tattoo artist. Calls can be traced, information deleted, computer code hacked. What remains? The sensation of injury. Arthur Kroker on Californian body cults: "You heard about slash-and-burn? People are cutting themselves with a razor, setting the wound alight with petrol, and then experiencing the exquisite pleasure of the healing process."

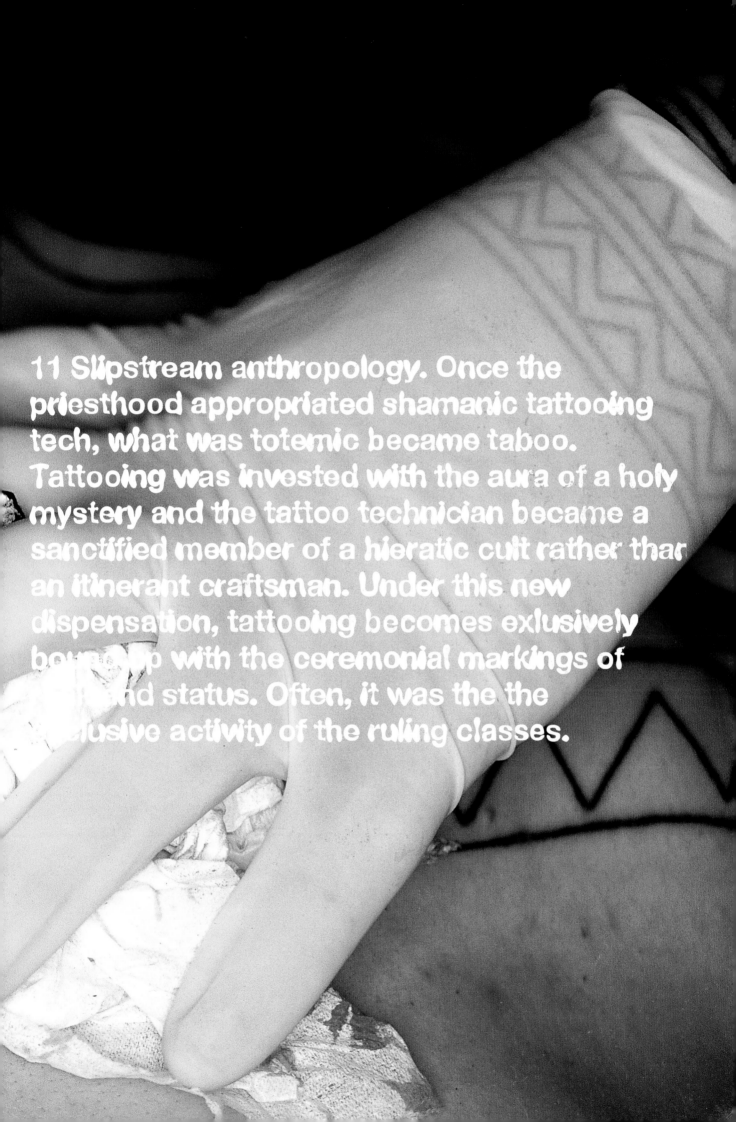

11 Slipstream anthropology. Once the priesthood appropriated shamanic tattooing tech, what was totemic became taboo. Tattooing was invested with the aura of a holy mystery and the tattoo technician became a sanctified member of a hieratic cult rather than an itinerant craftsman. Under this new dispensation, tattooing becomes exlusively bound up with the ceremonial markings of and status. Often, it was the the lusive activity of the ruling classes.

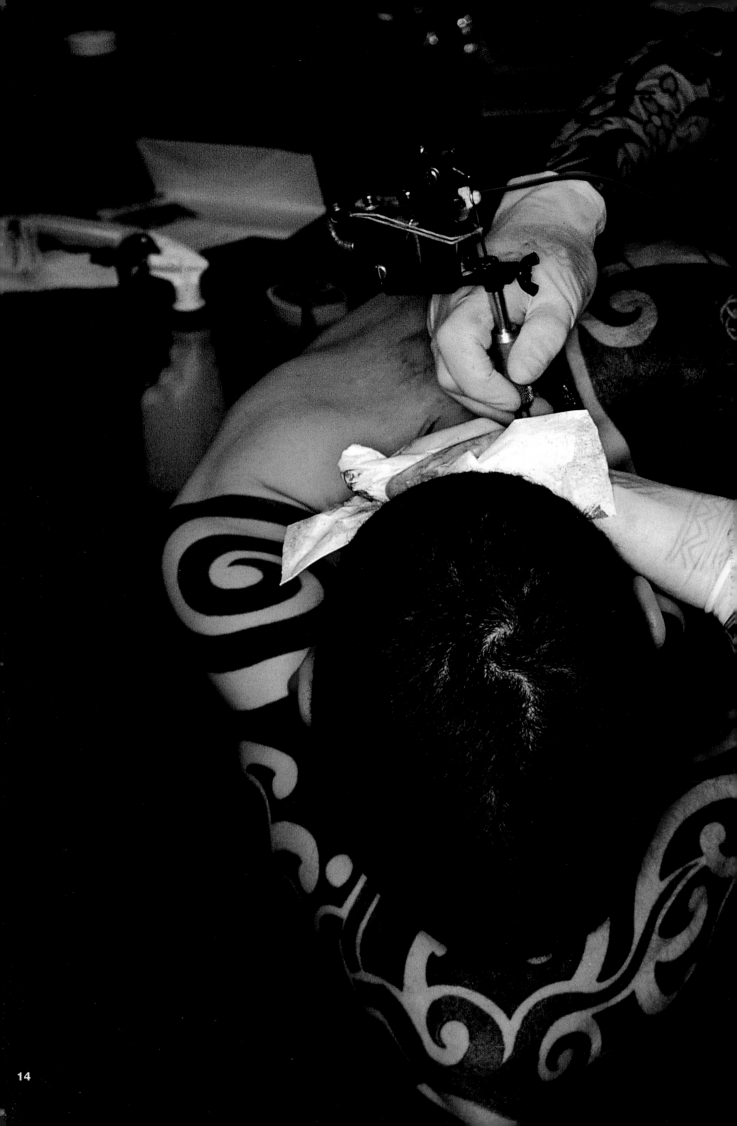

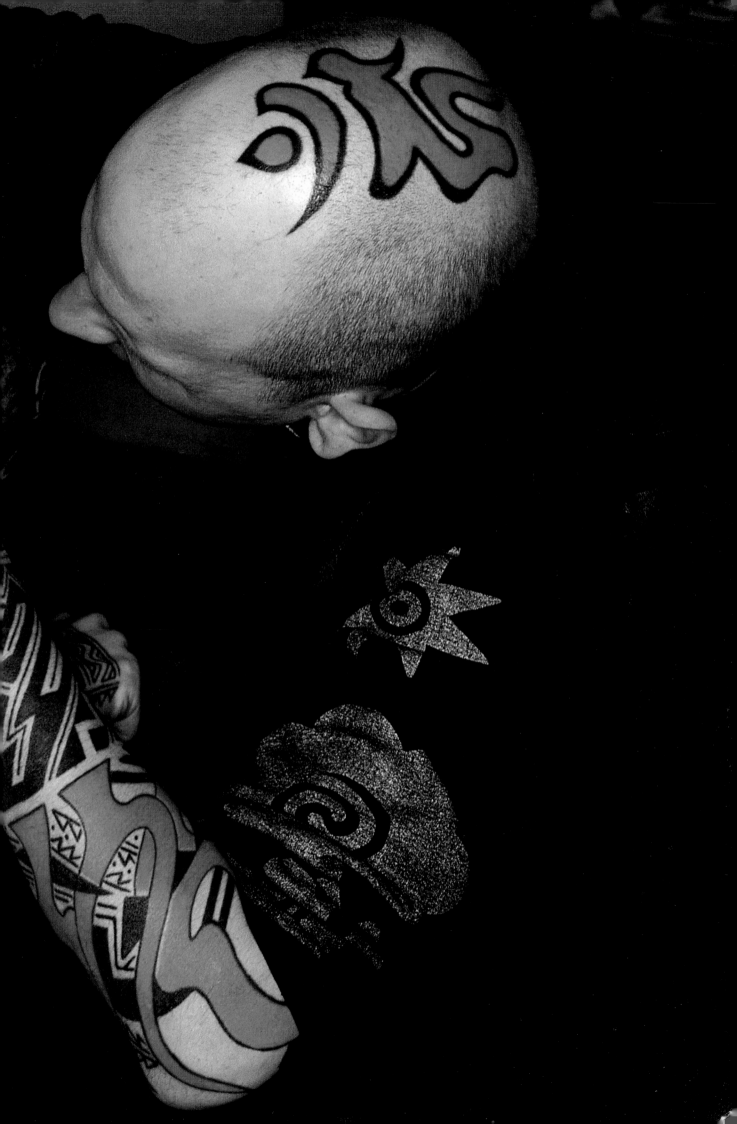

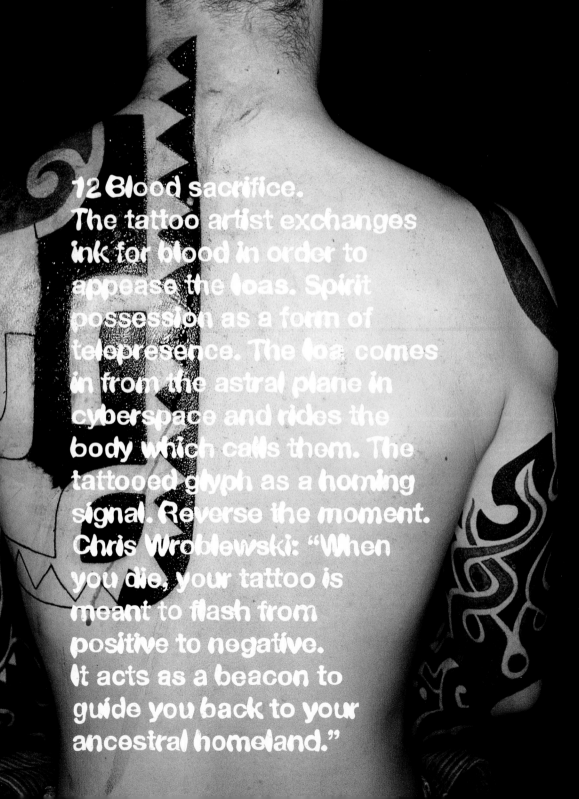

12 Blood sacrifice.
The tattoo artist exchanges
ink for blood in order to
appease the loas. Spirit
possession as a form of
telepresence. The loa comes
in from the astral plane in
cyberspace and rides the
body which calls them. The
tattooed glyph as a homing
signal. Reverse the moment.
Chris Wroblewski: "When
you die, your tattoo is
meant to flash from
positive to negative.
It acts as a beacon to
guide you back to your
ancestral homeland."

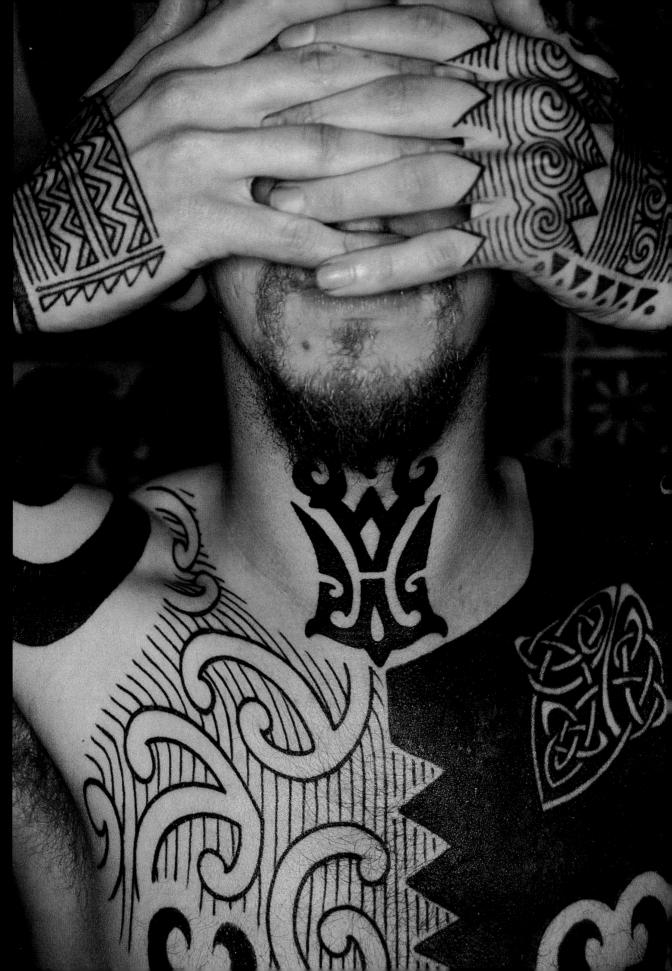

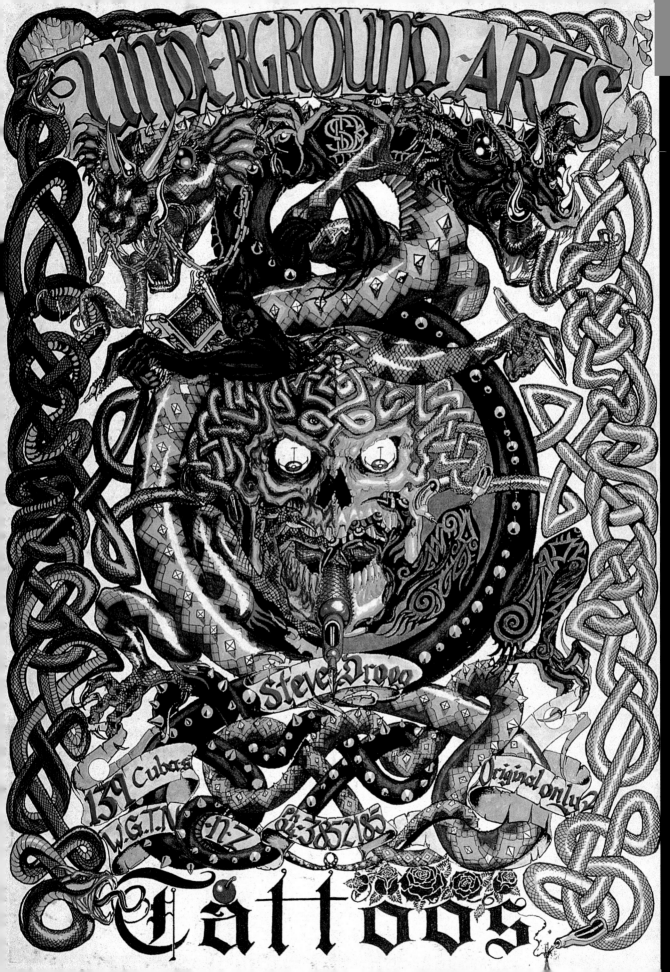

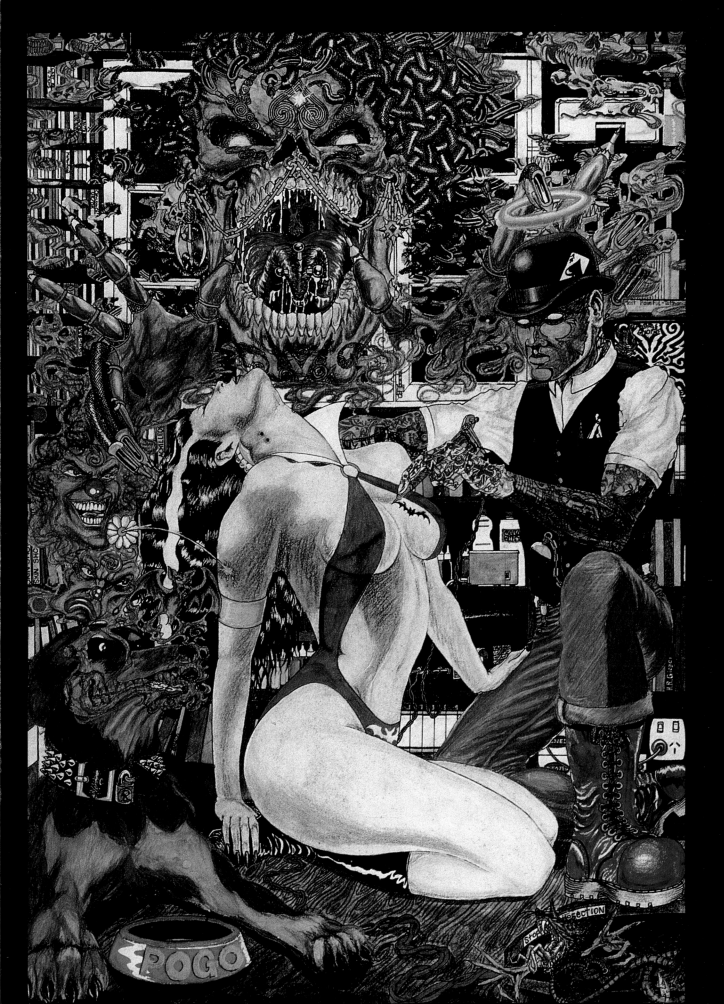

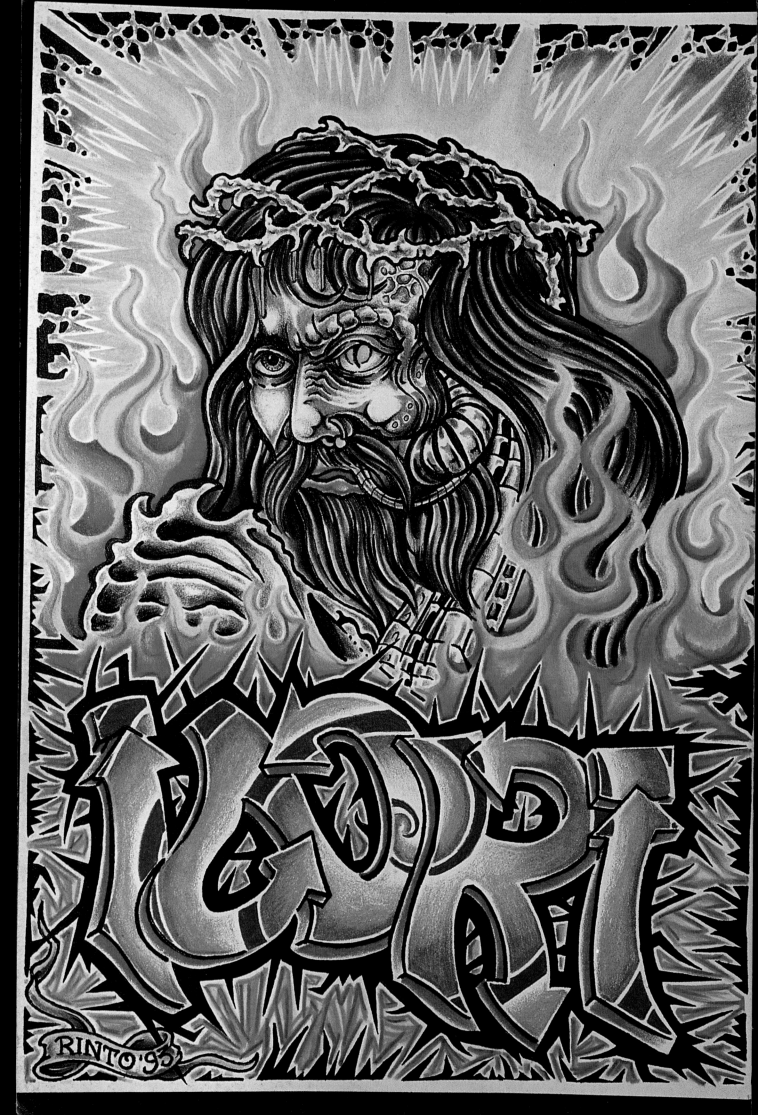

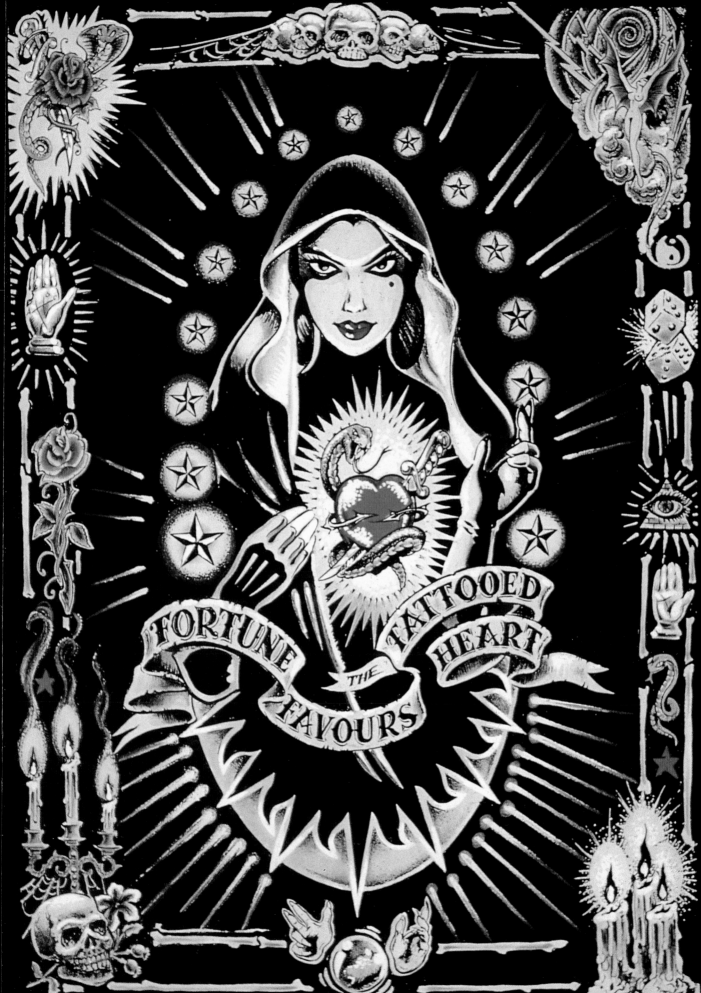

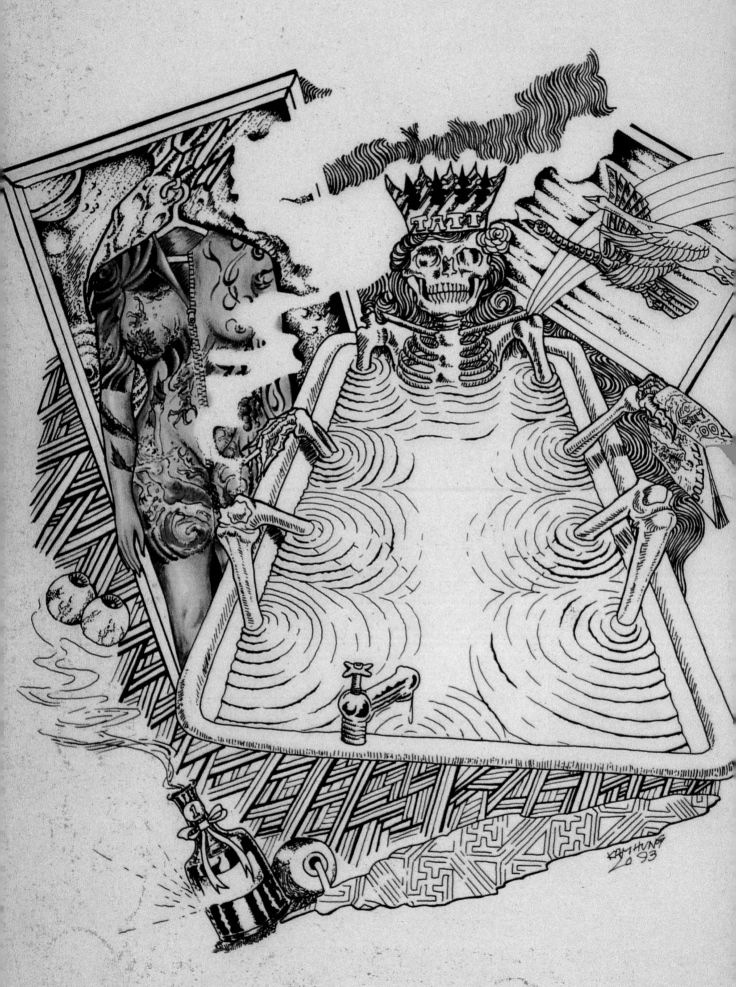

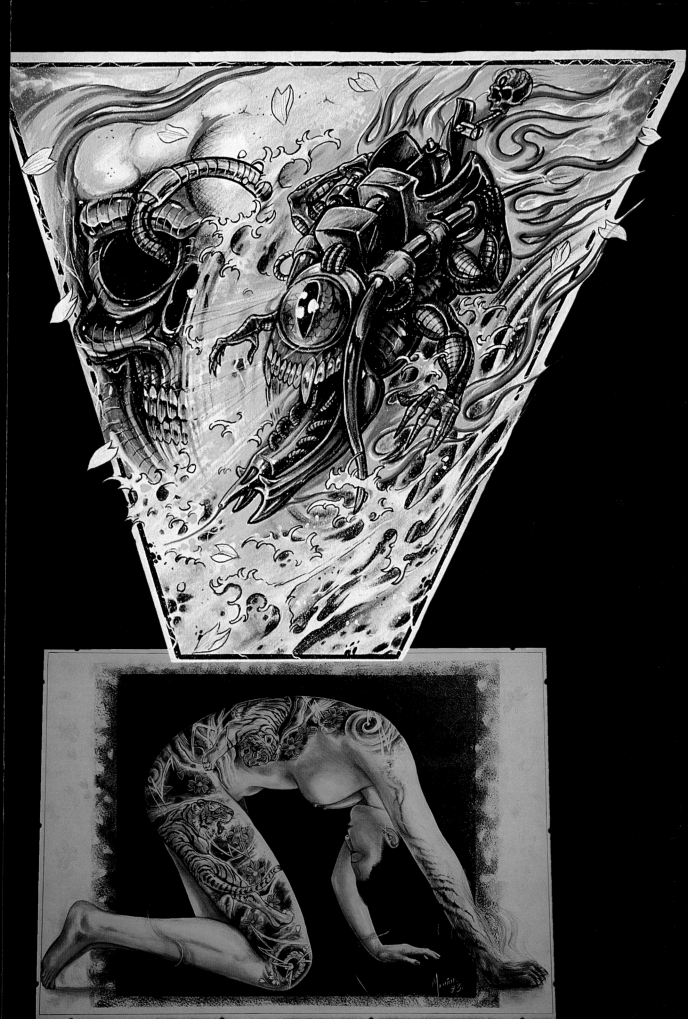

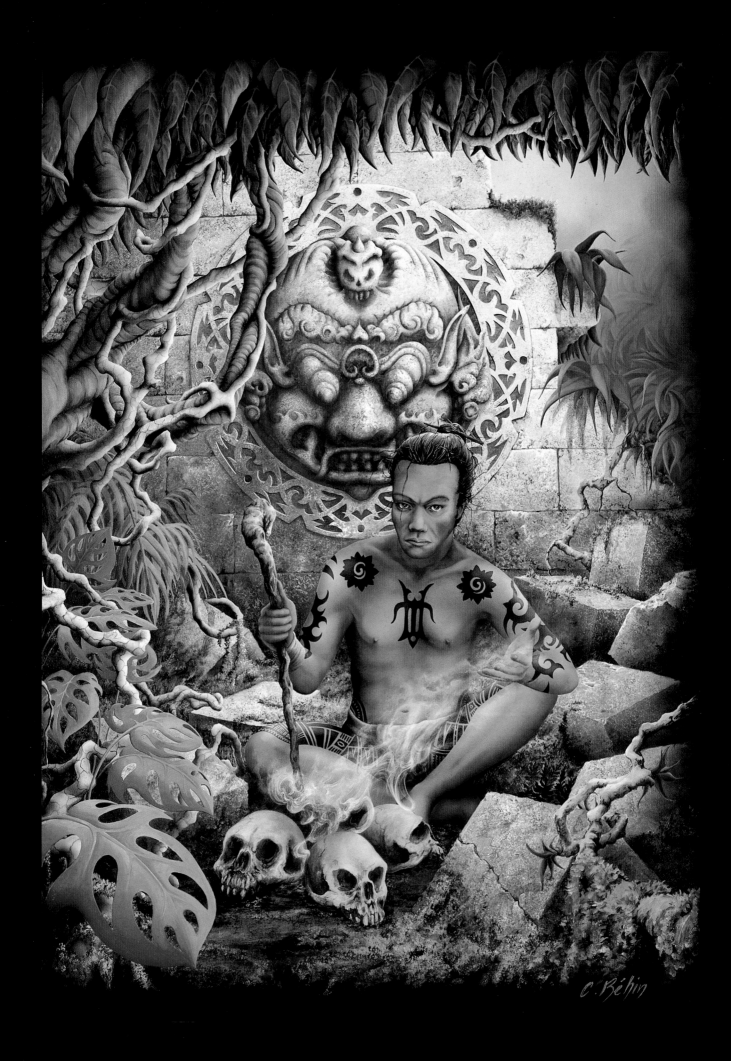

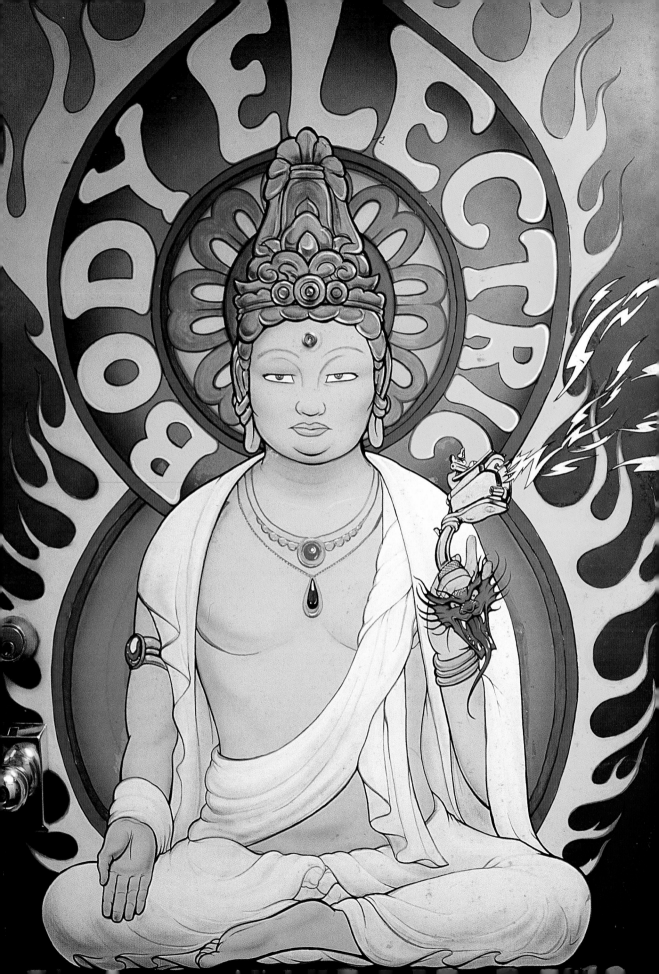

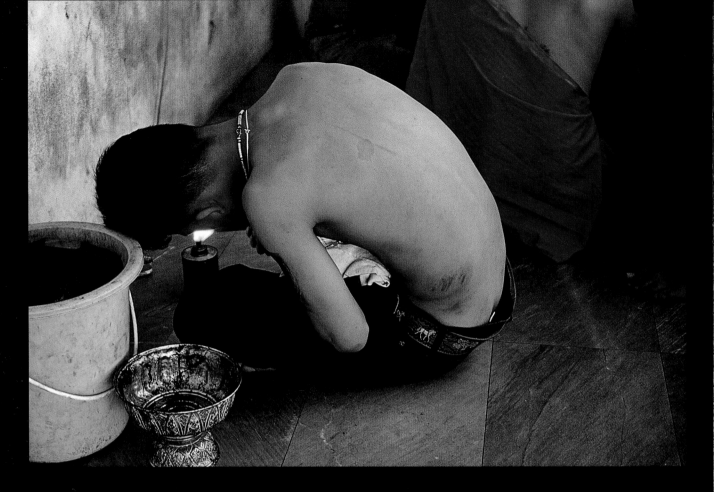

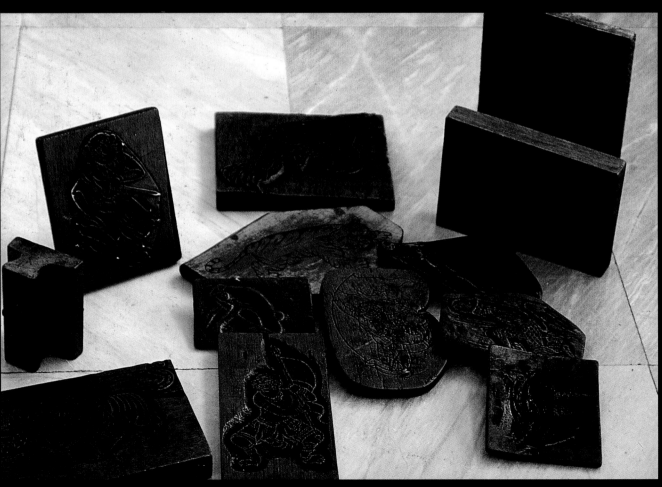

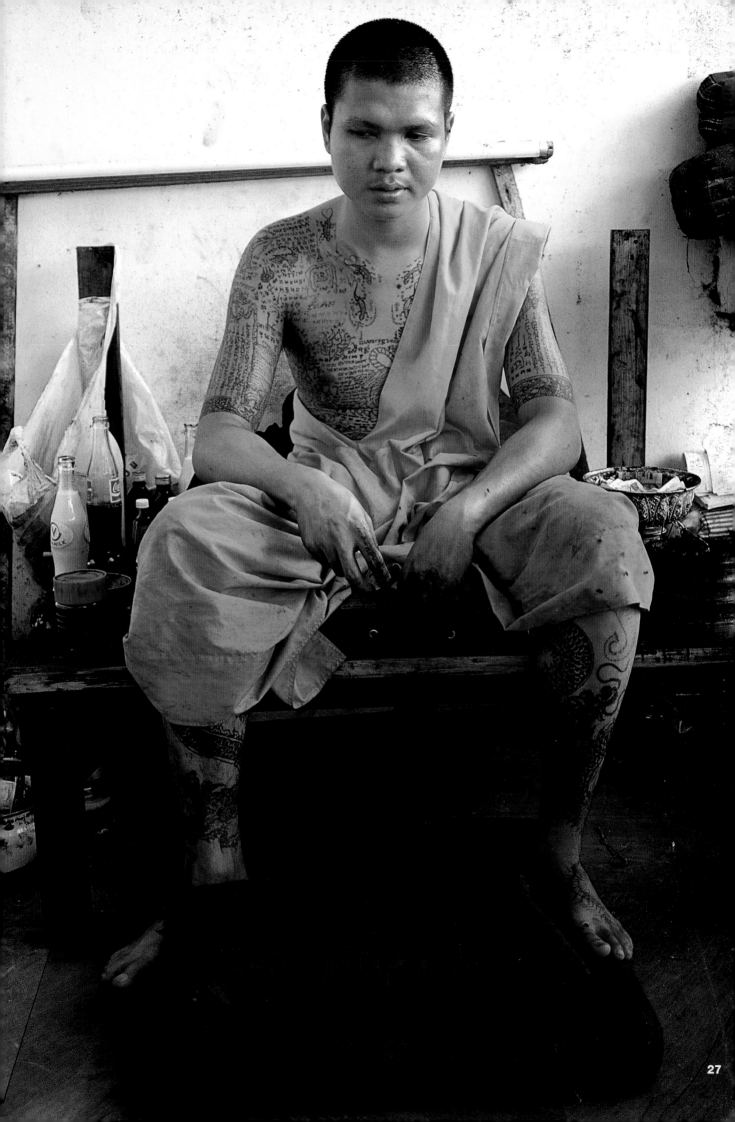

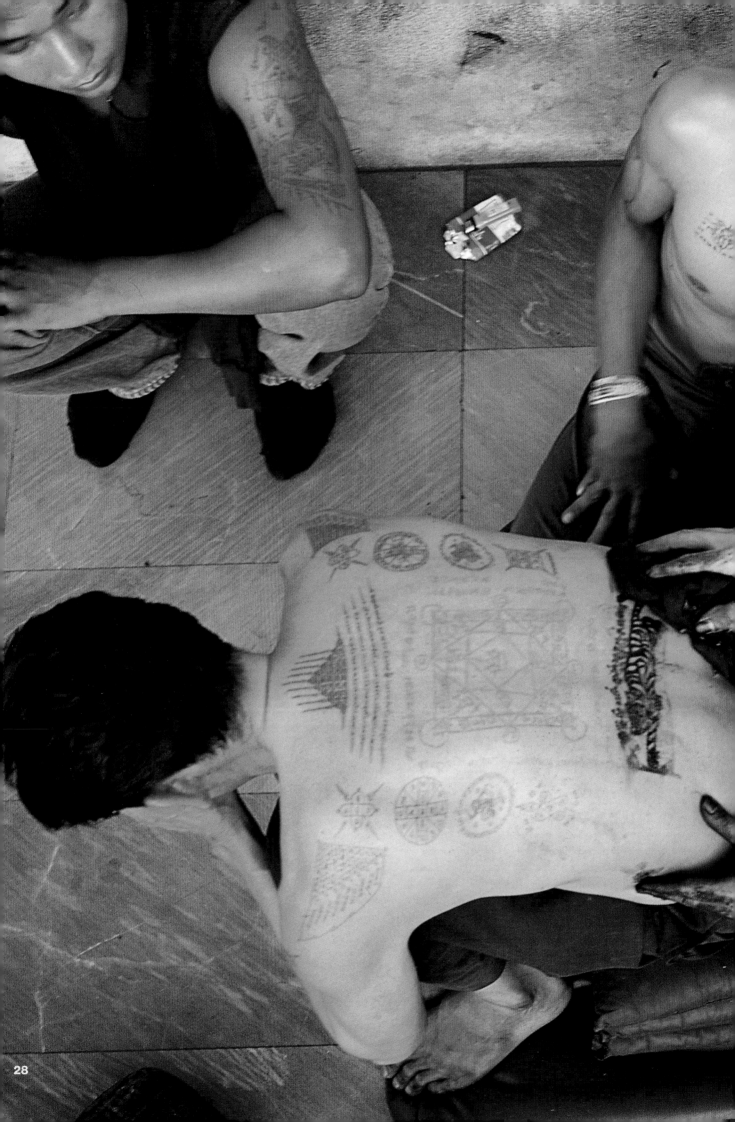

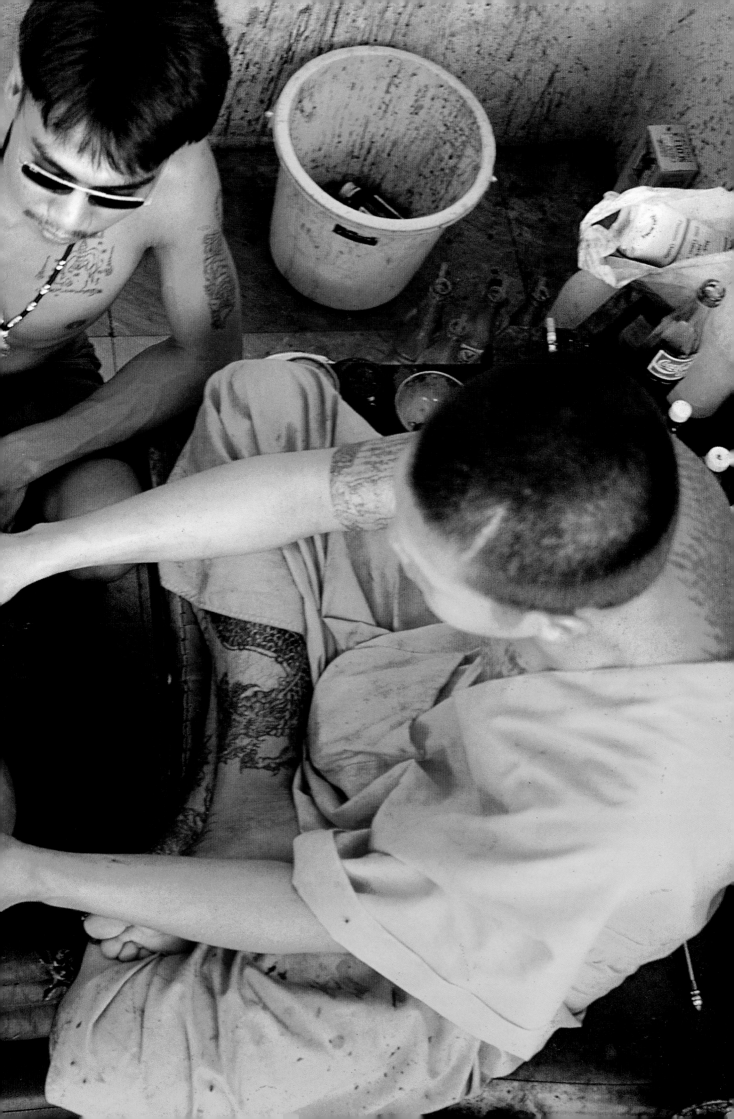

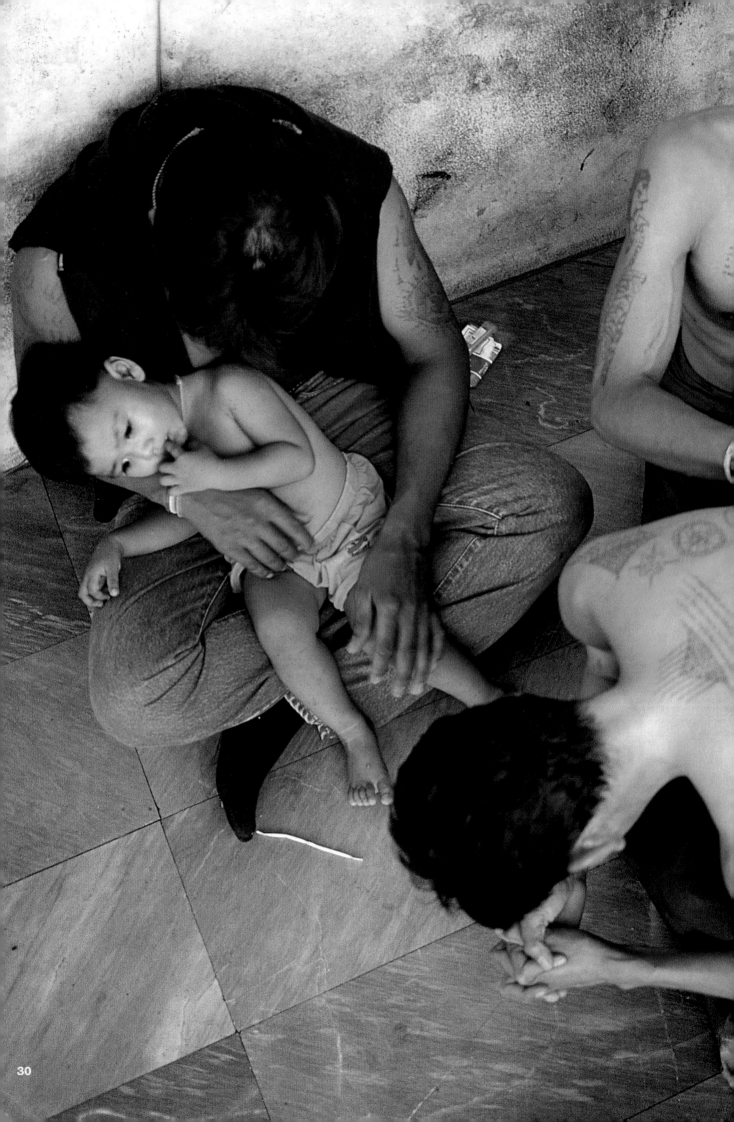

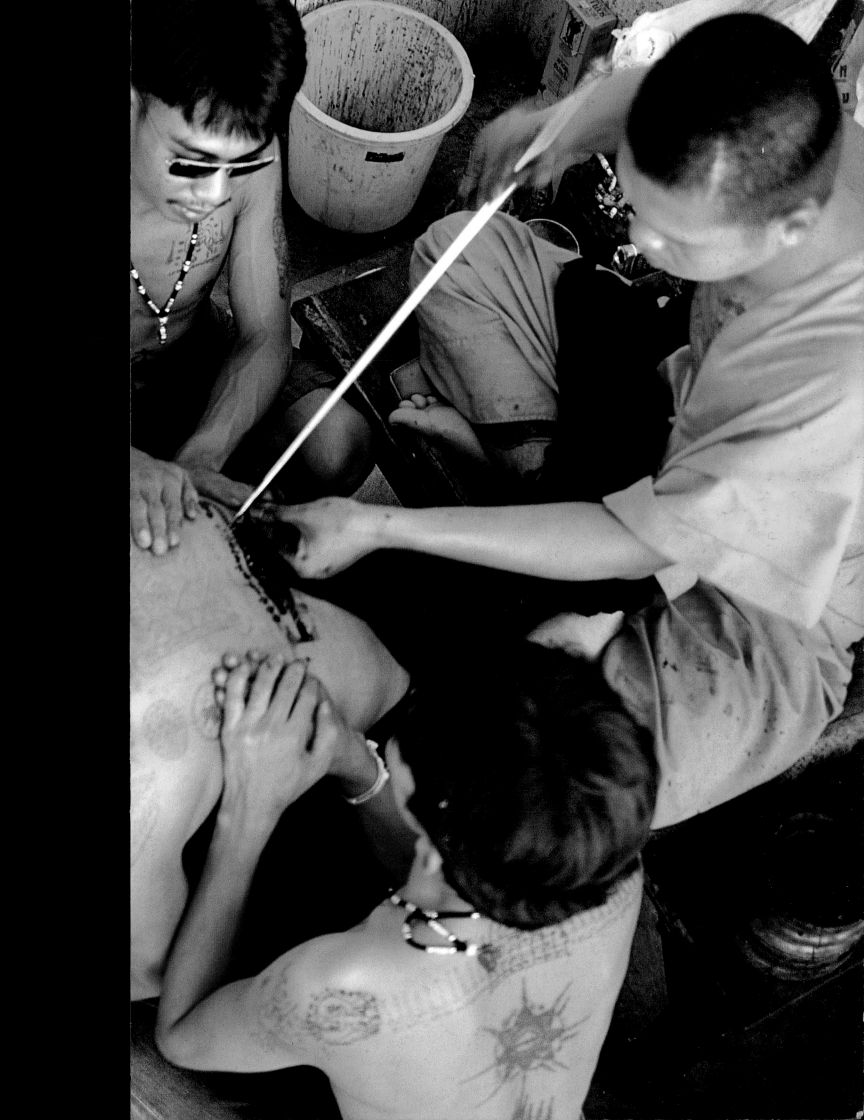

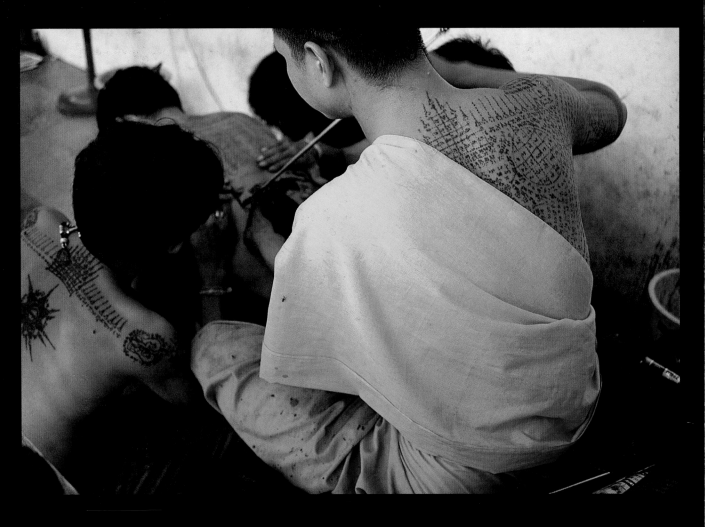

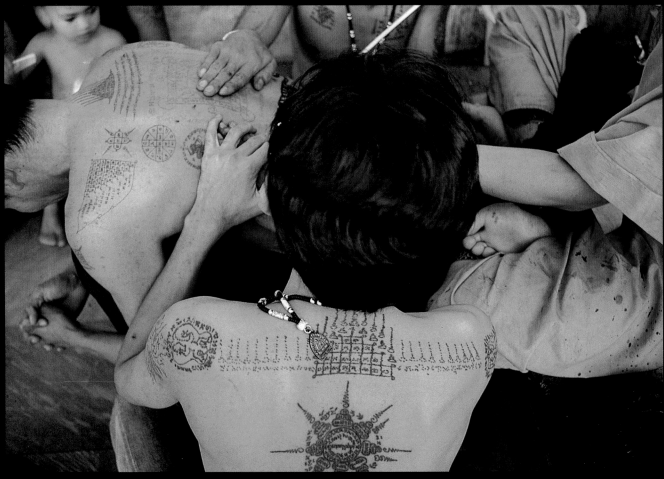

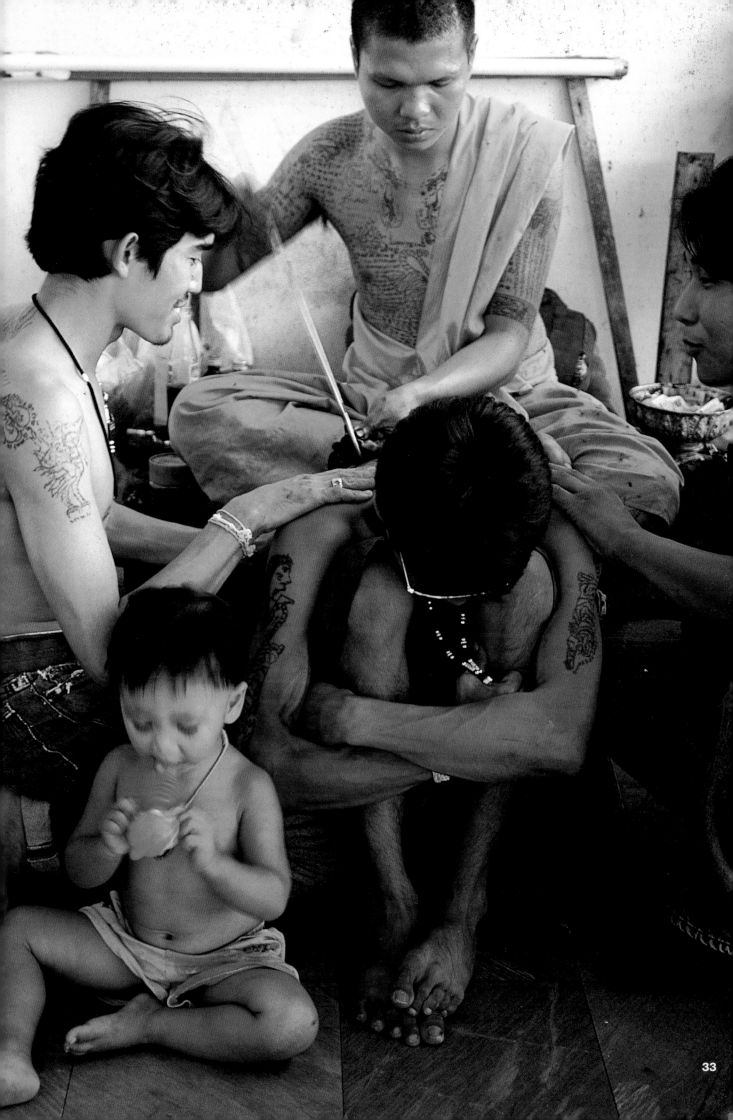

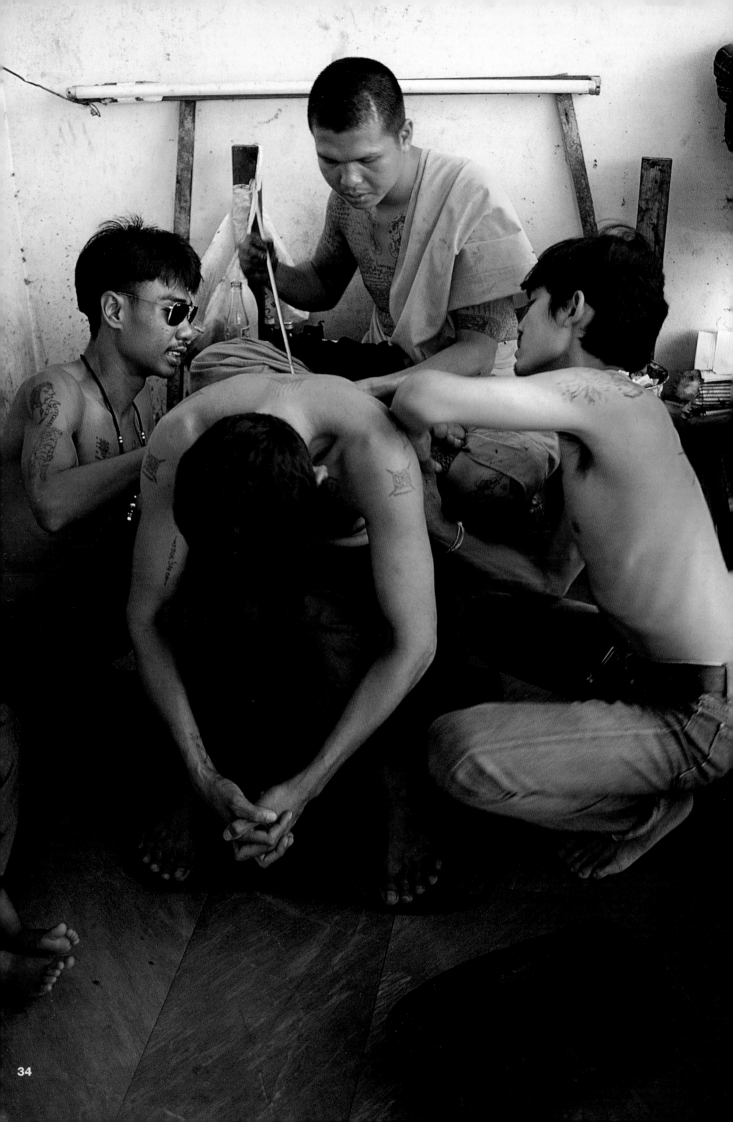

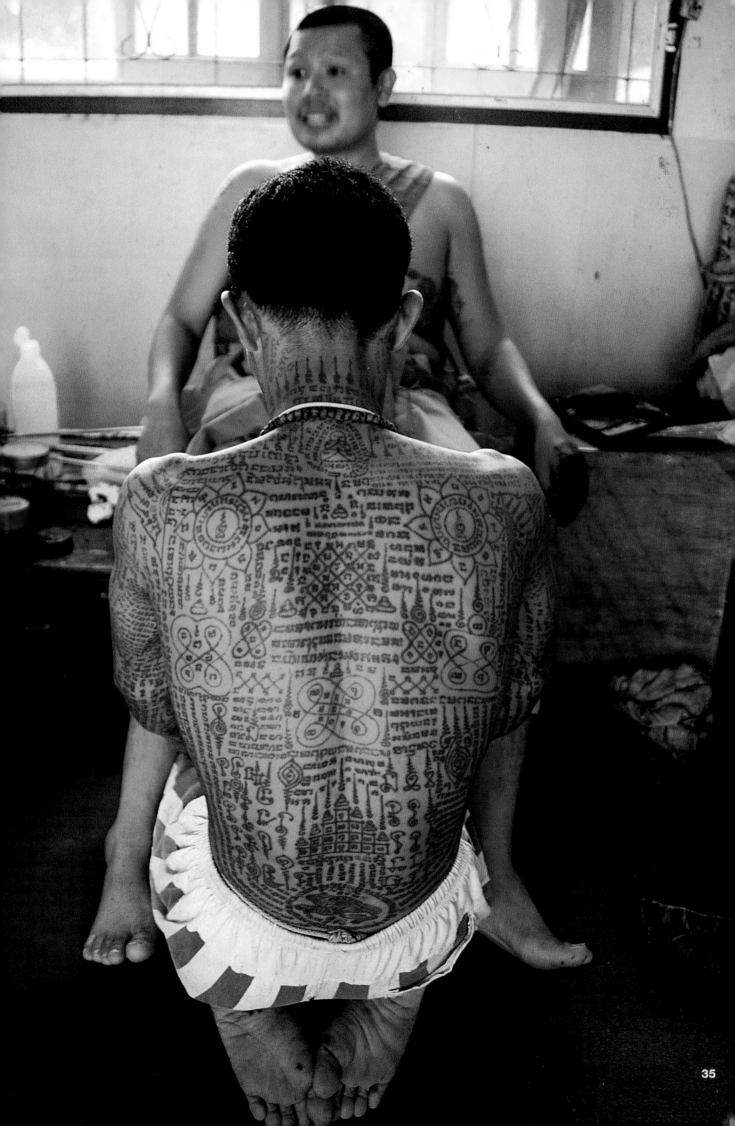

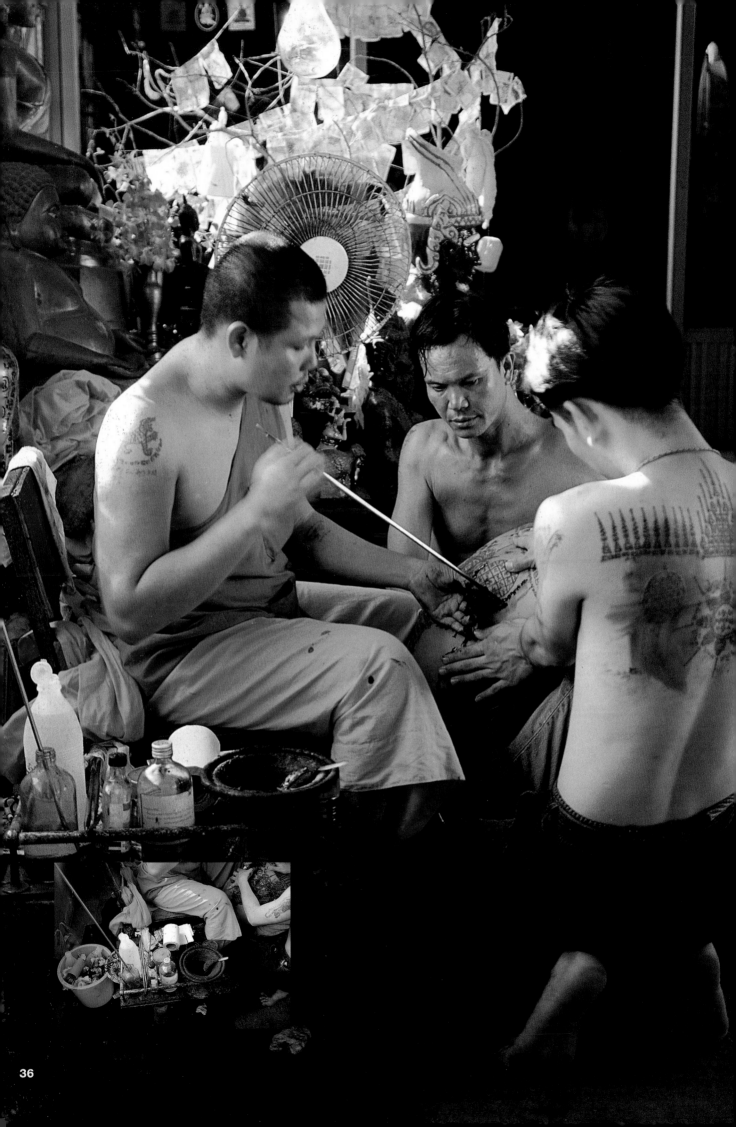

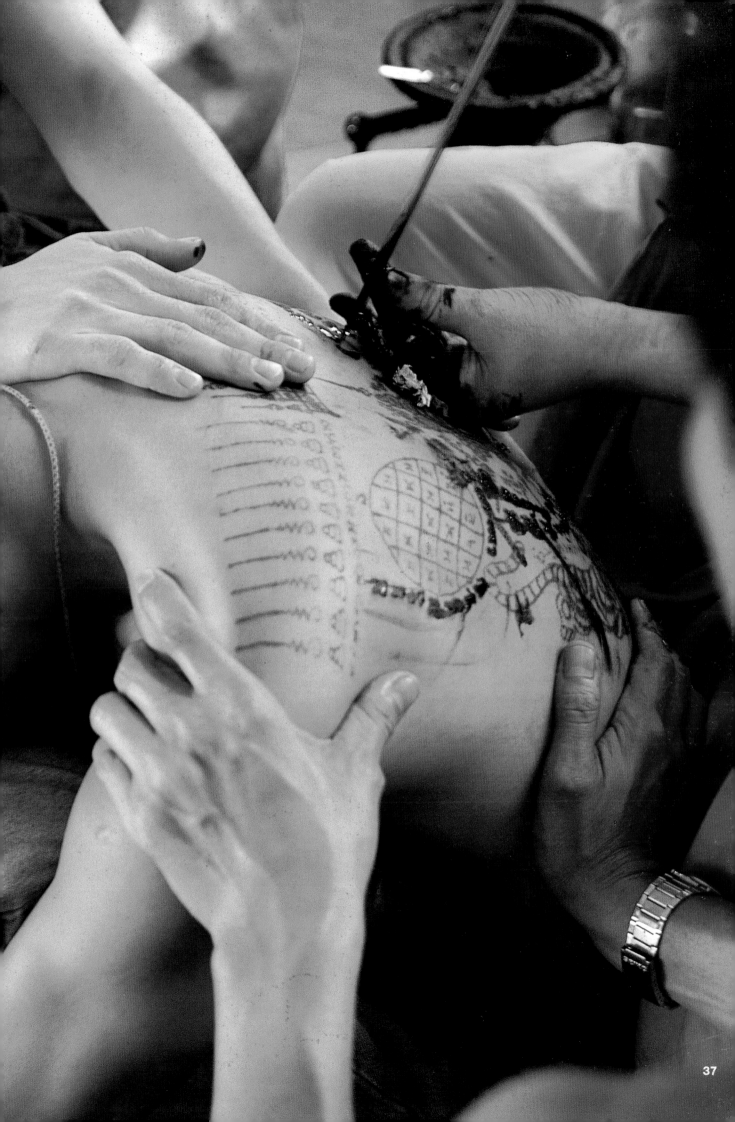

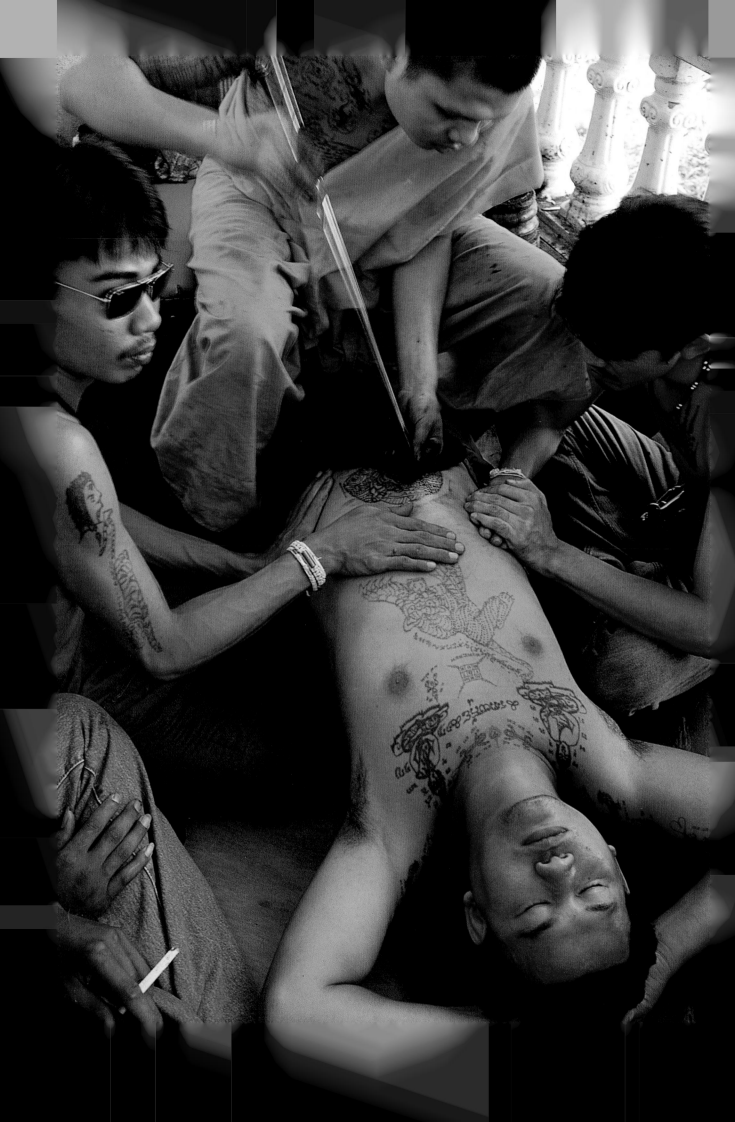

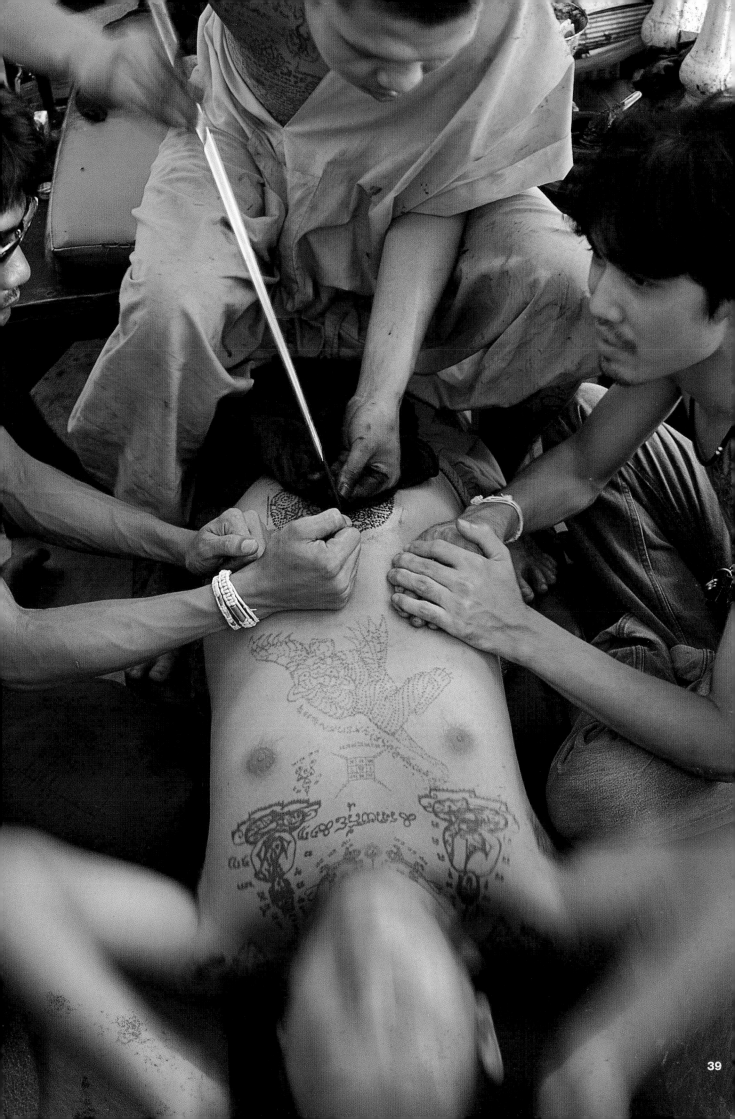

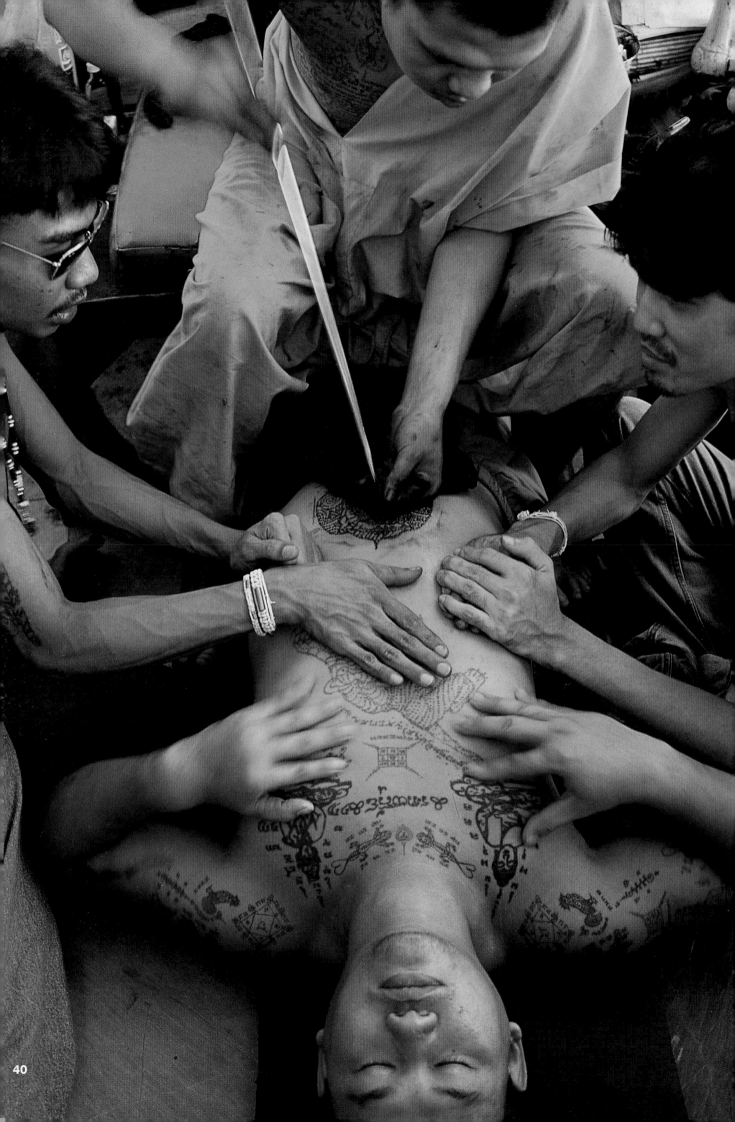

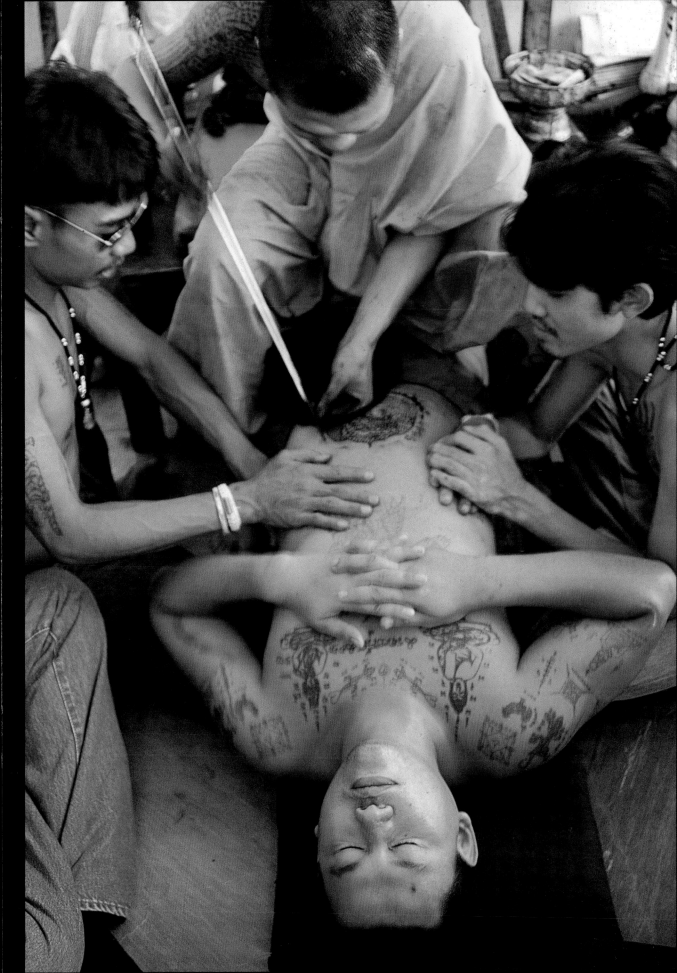

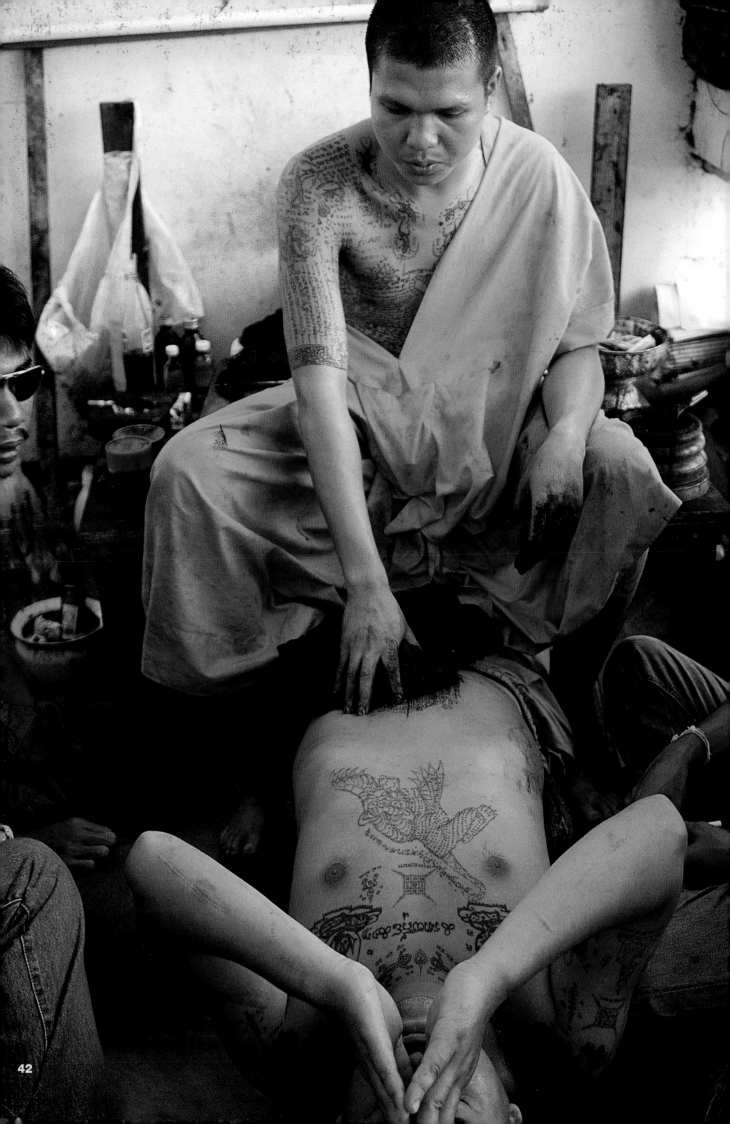

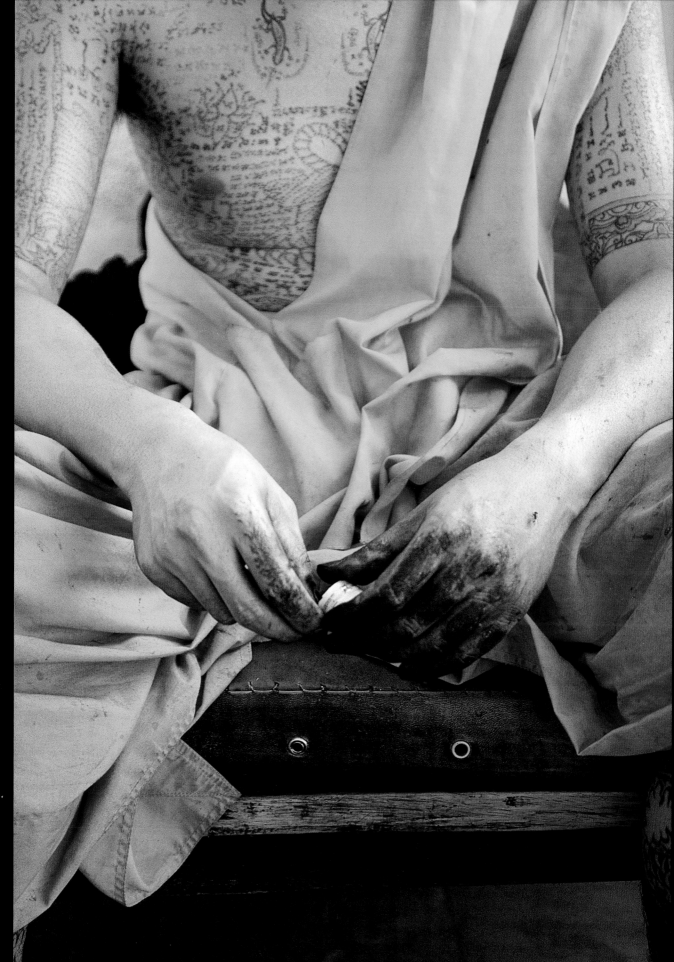

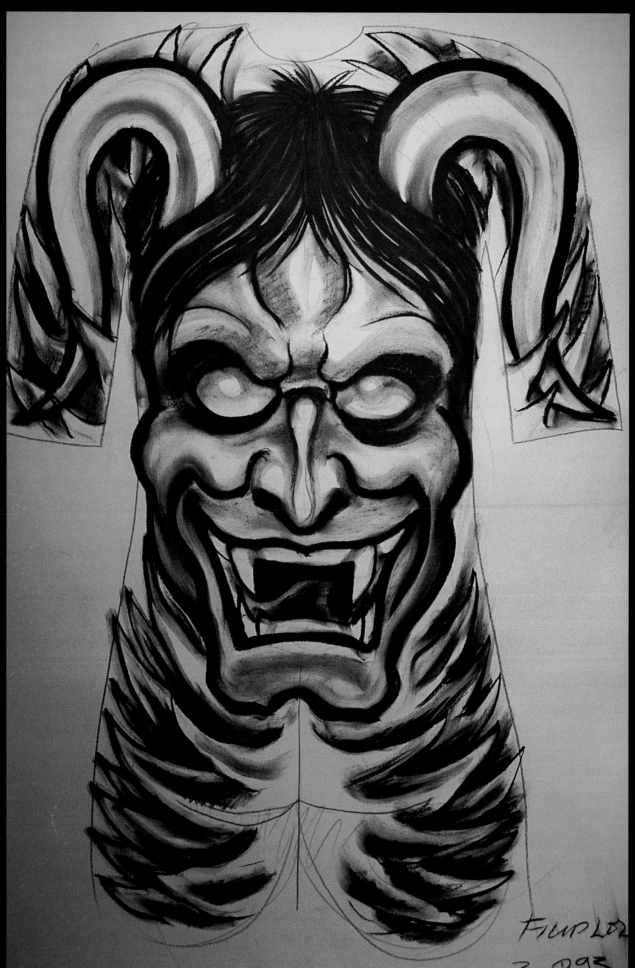

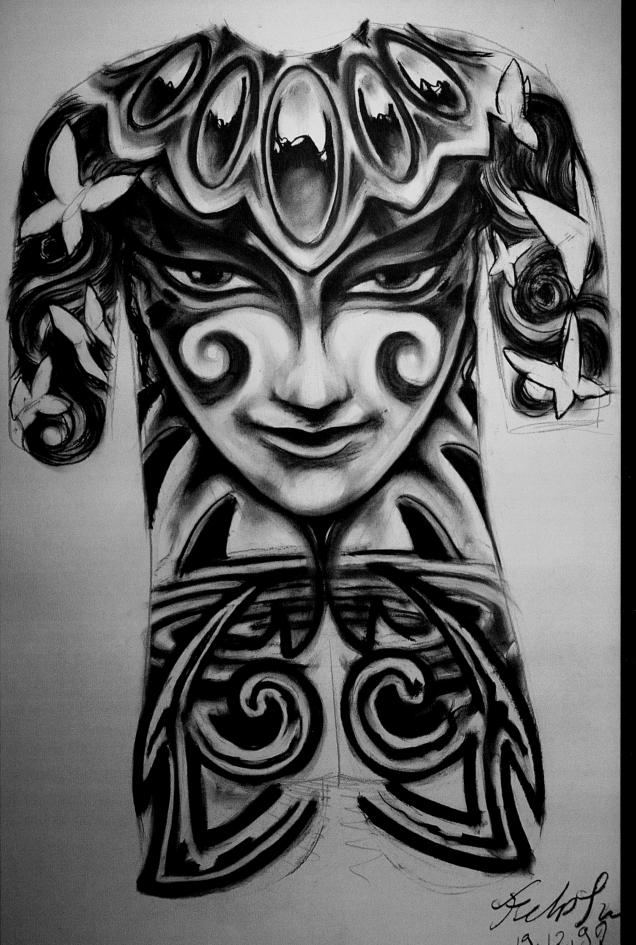

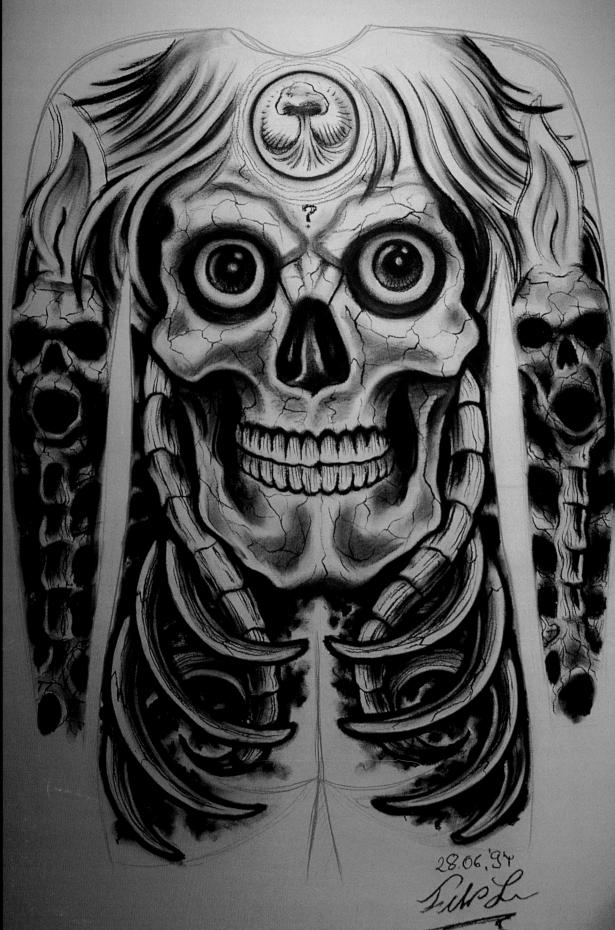

28.06.'94

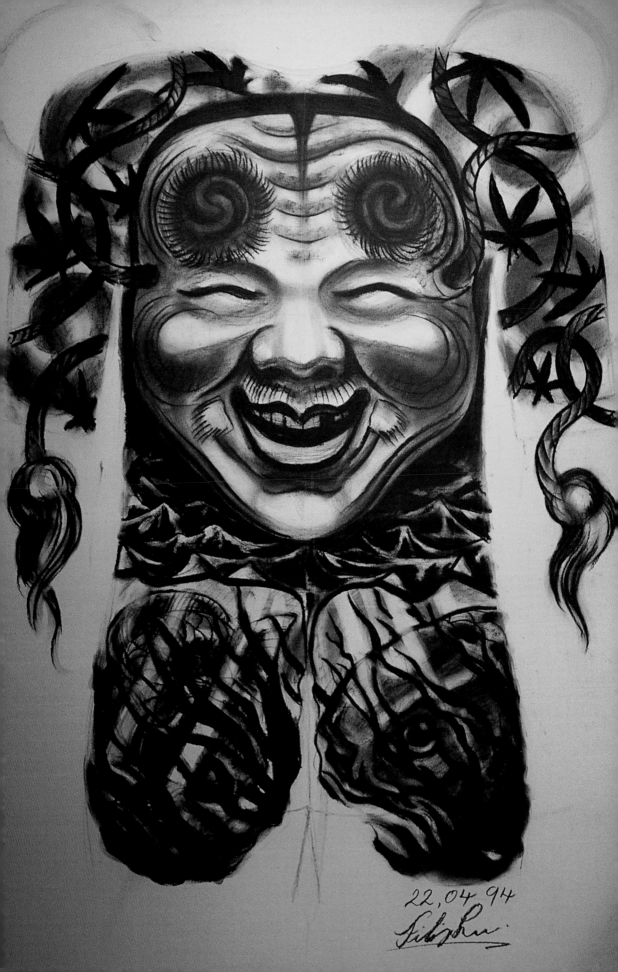

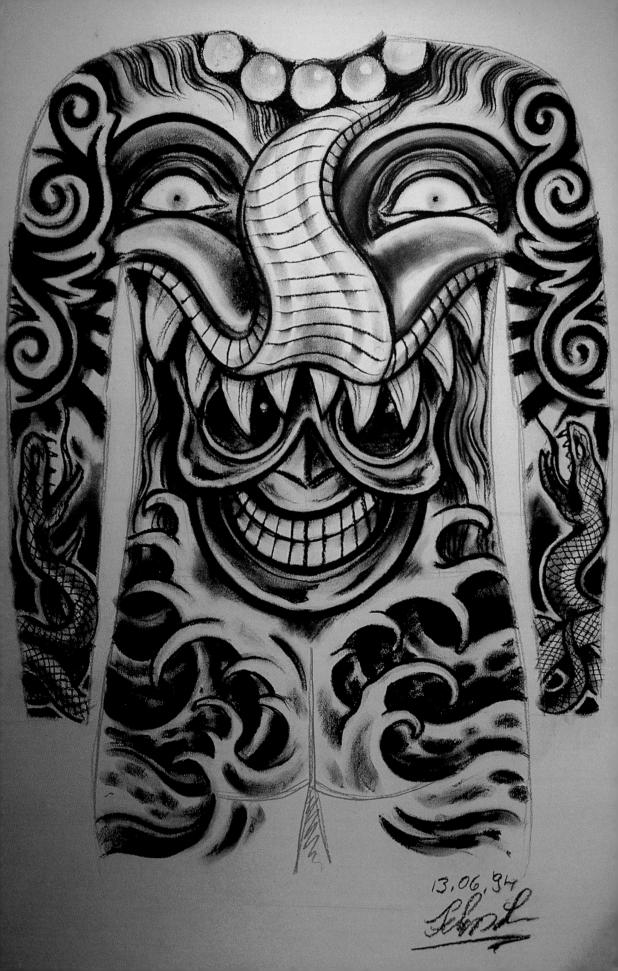

13.06.94

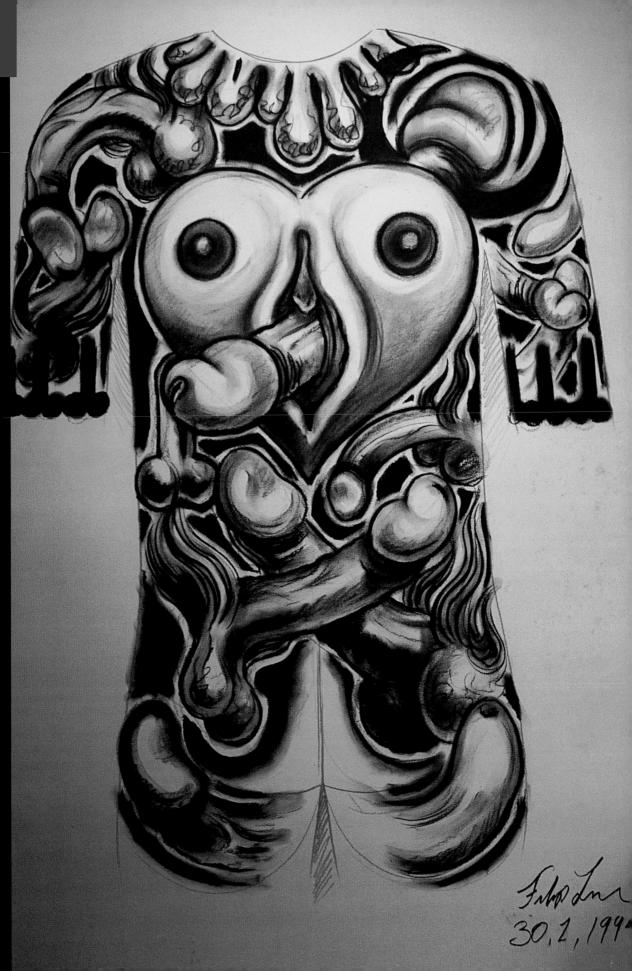

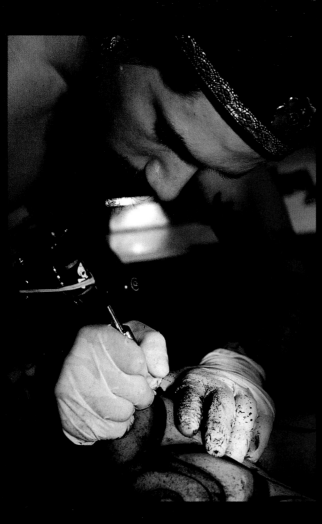

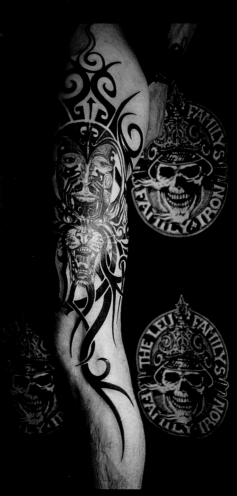

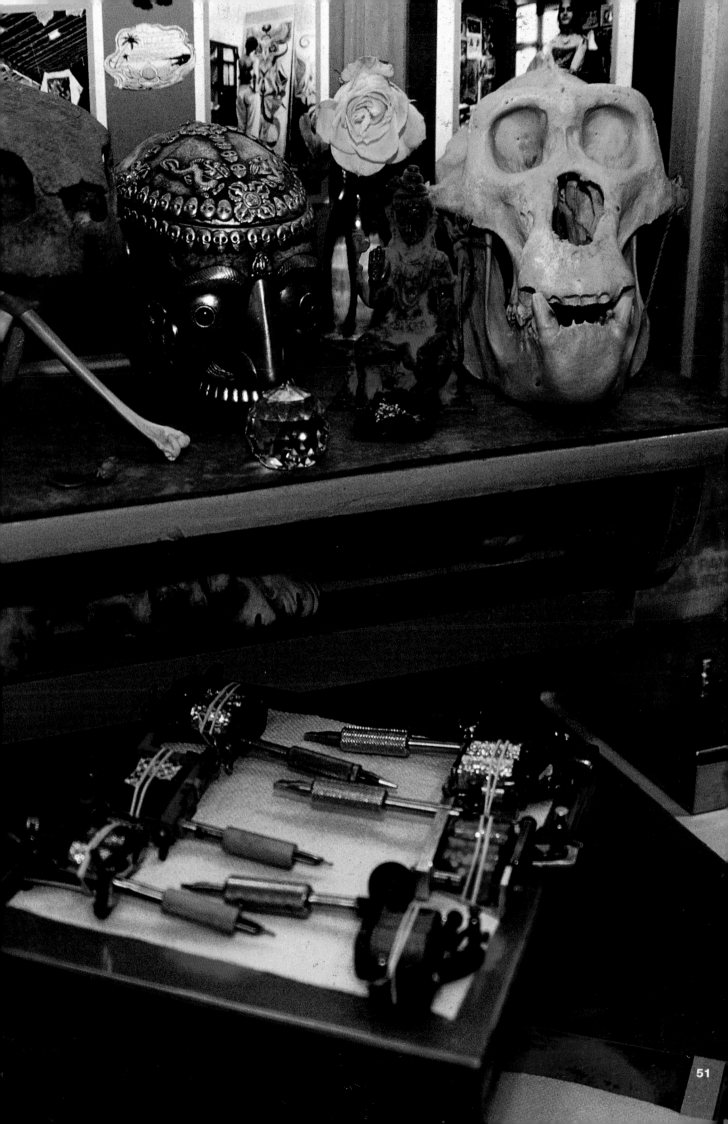

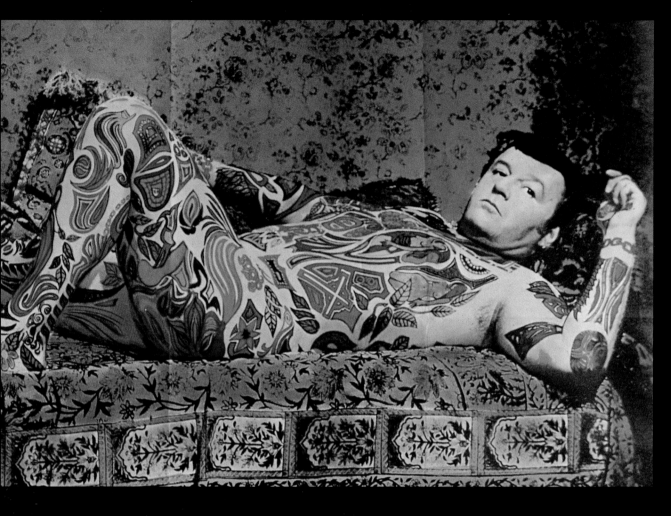

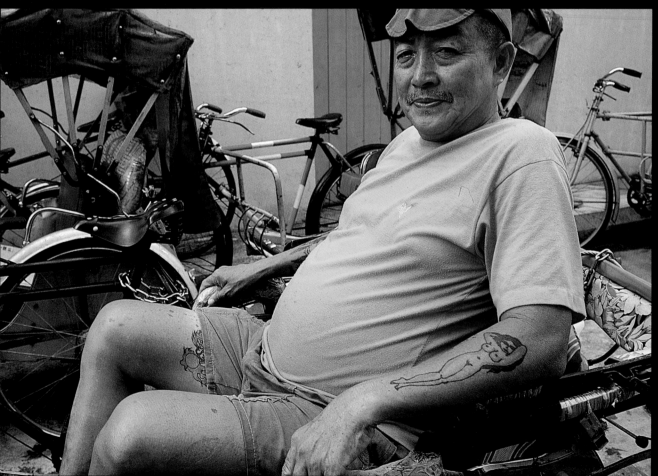

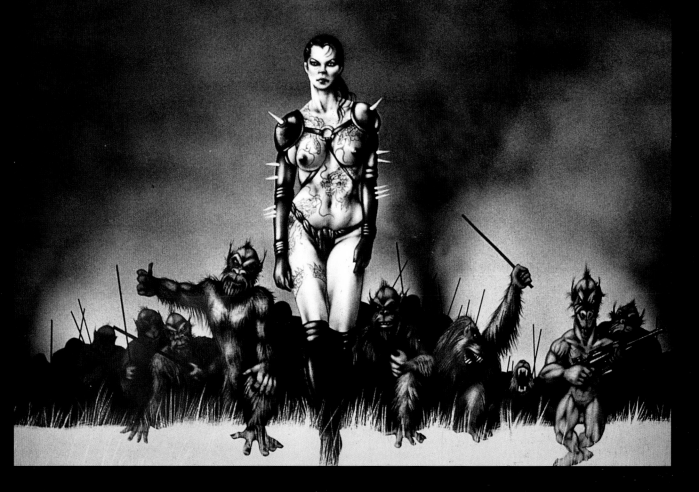

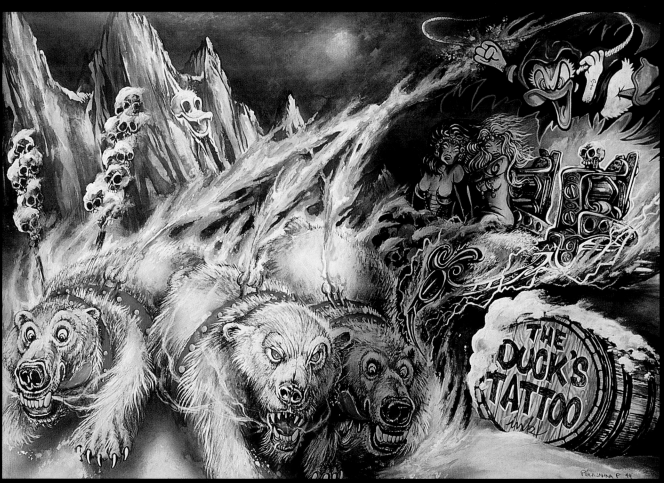

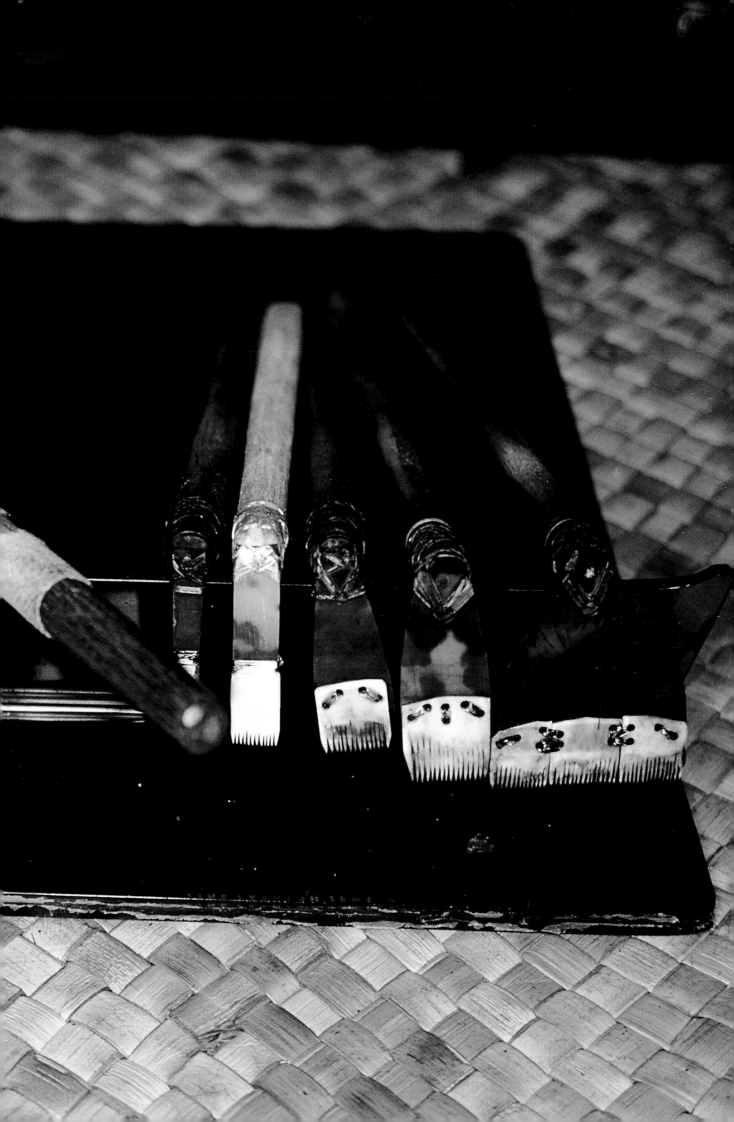

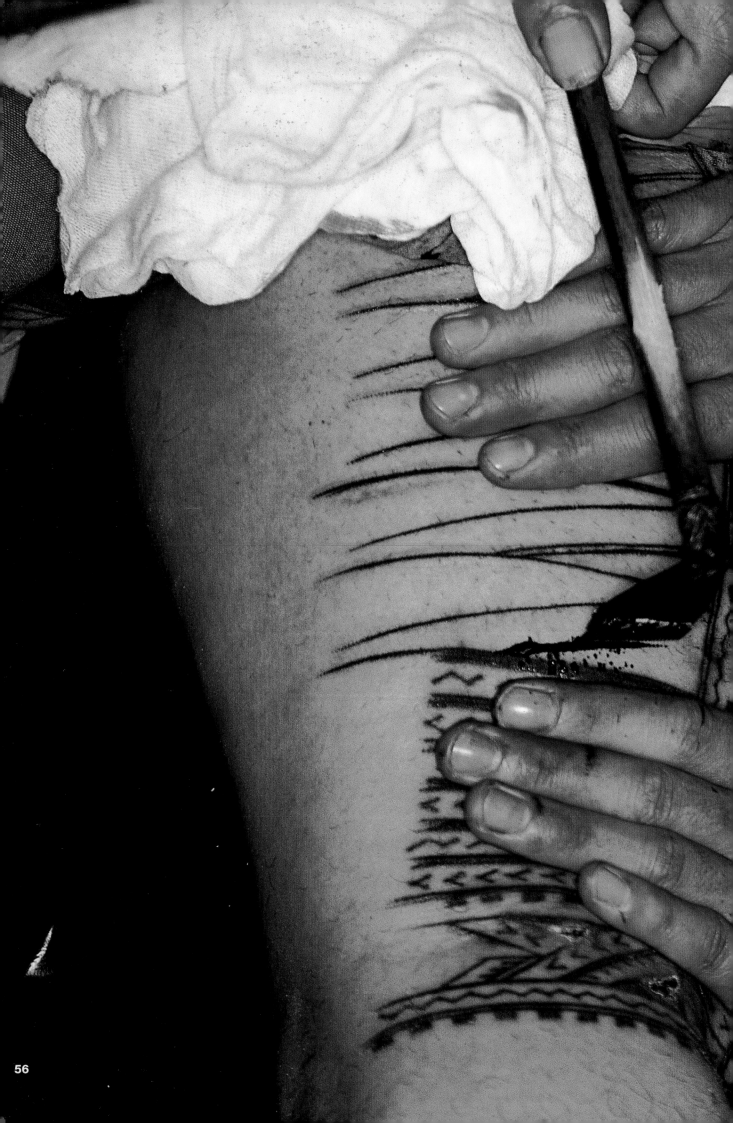

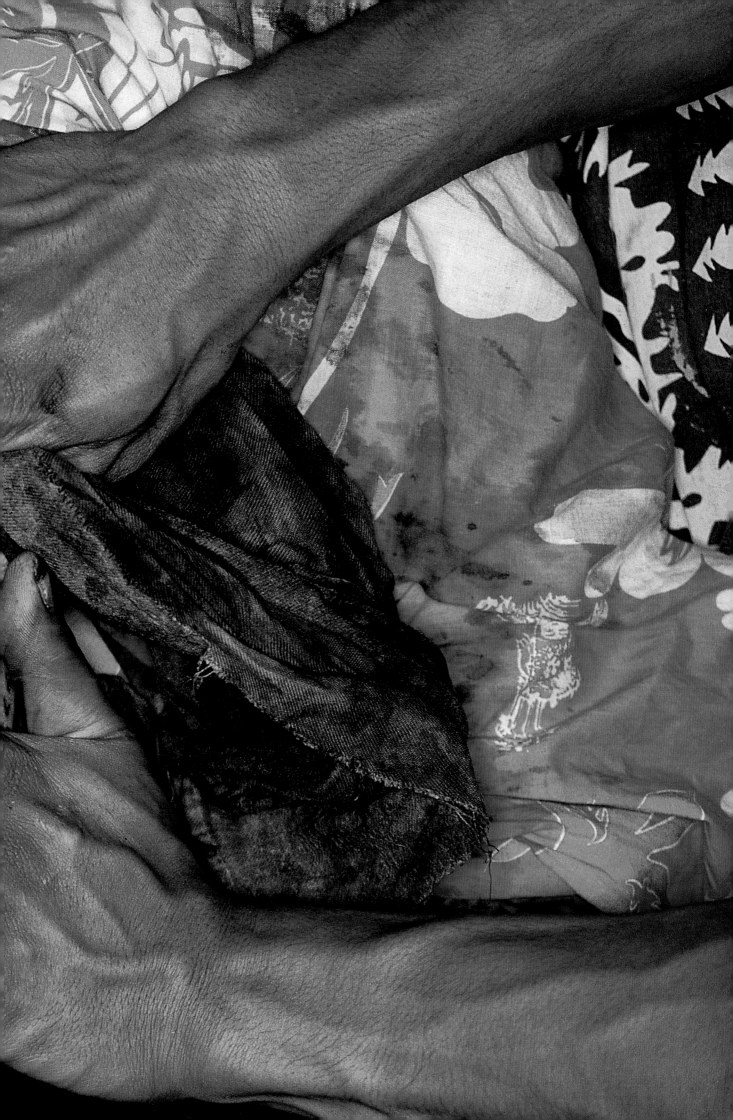

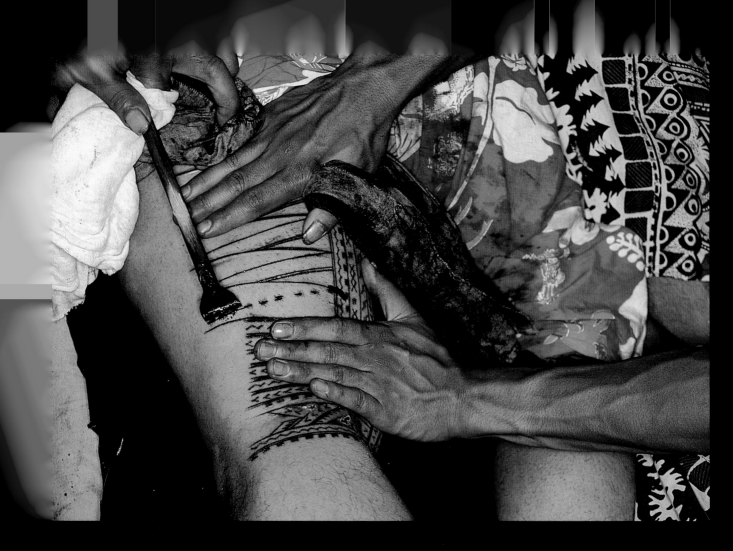
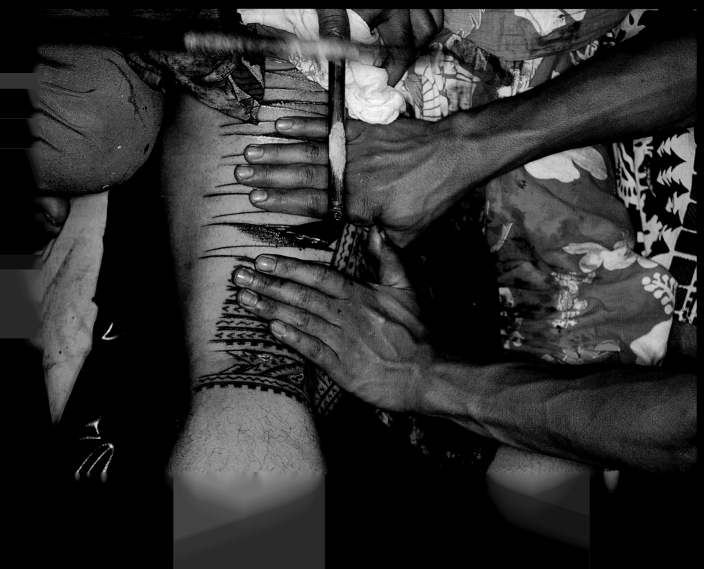

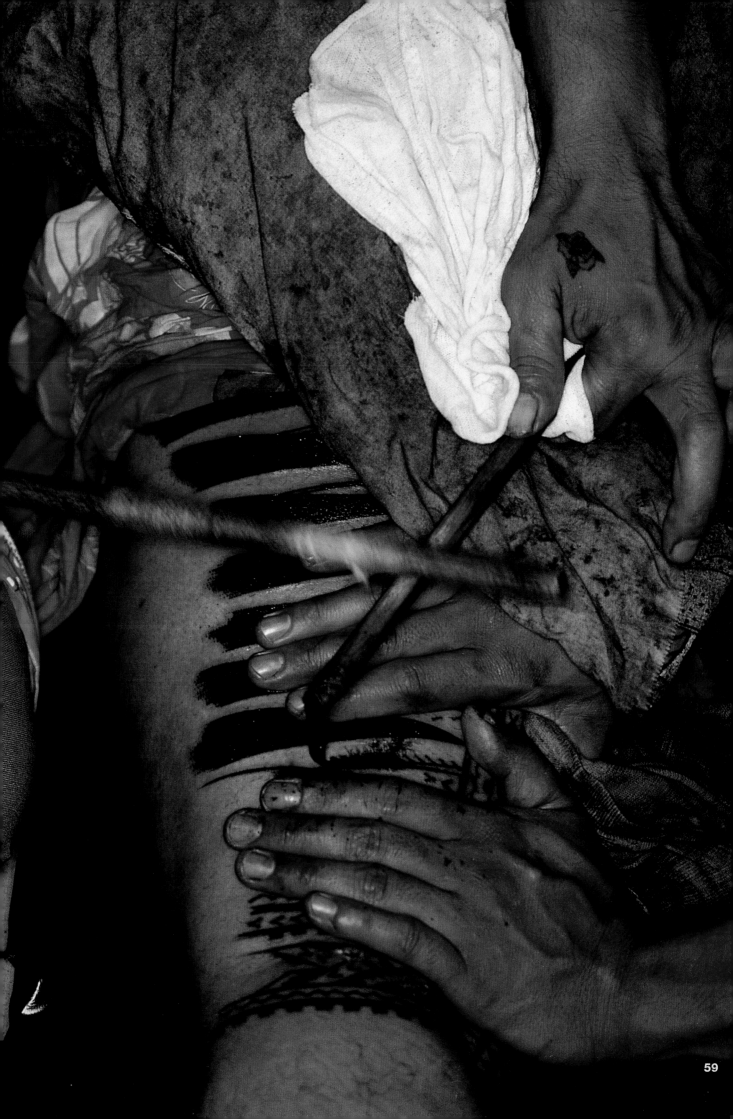

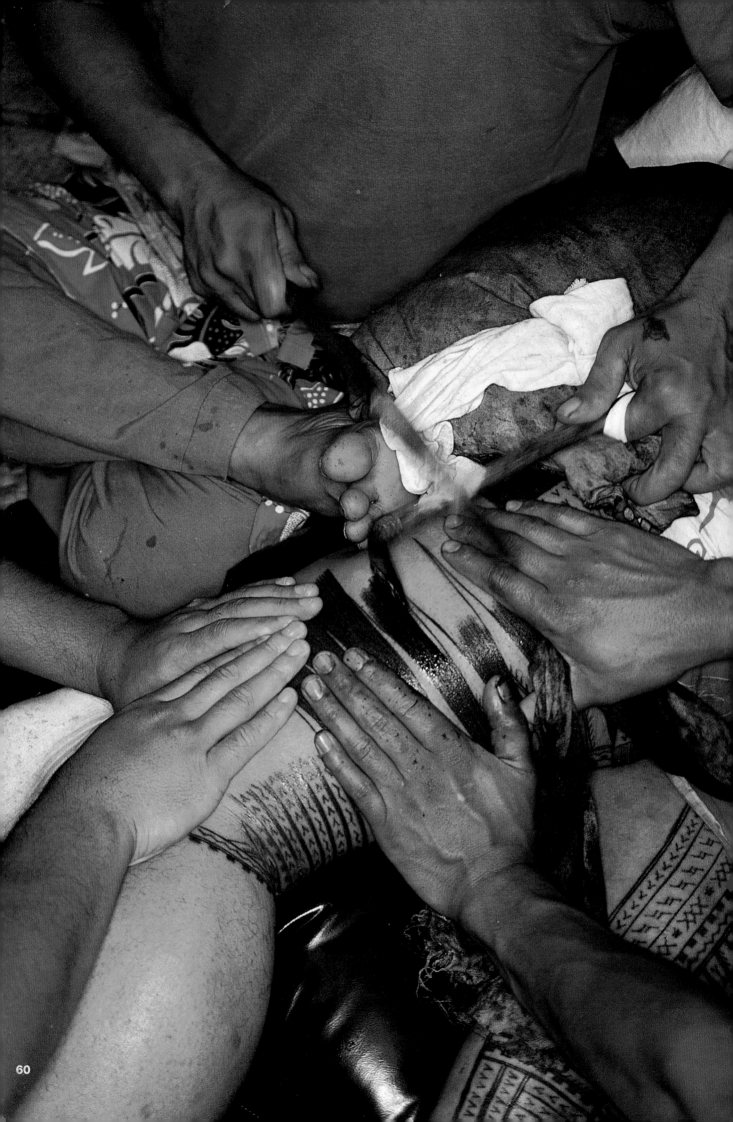

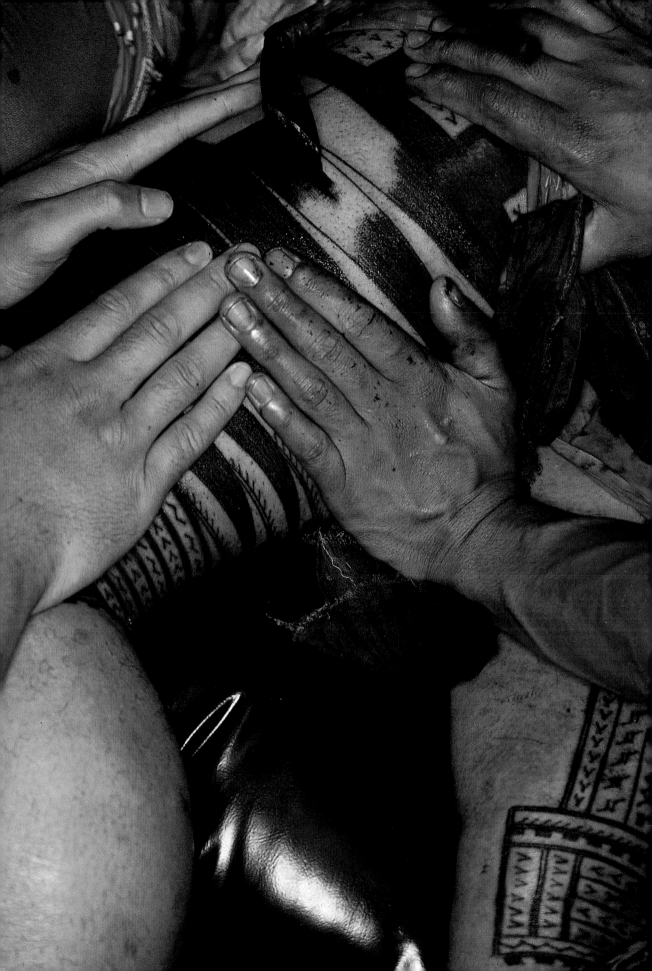

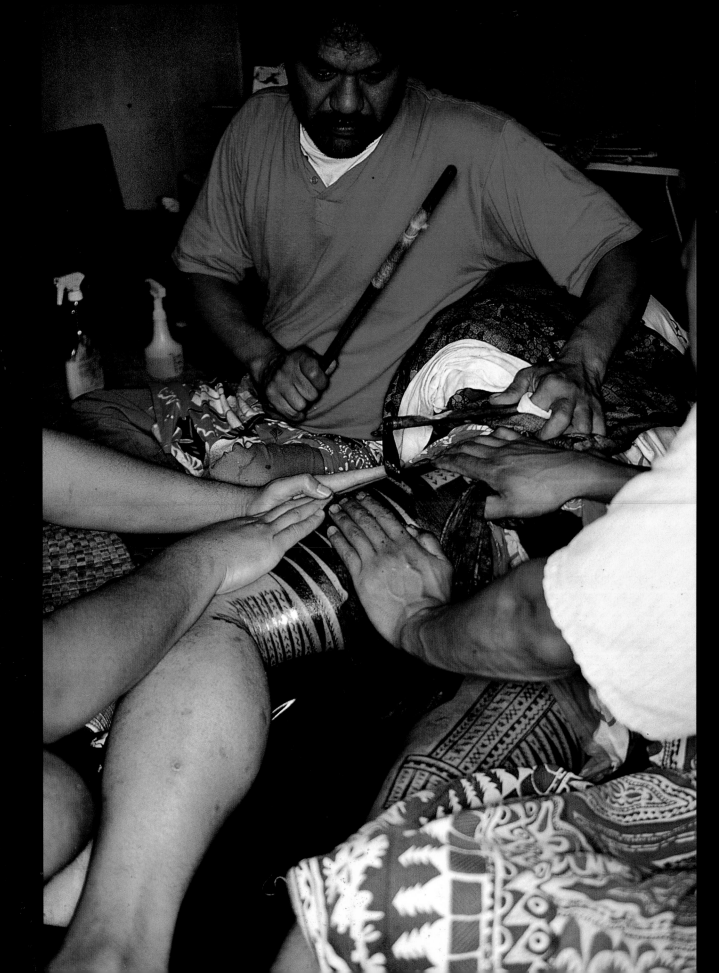

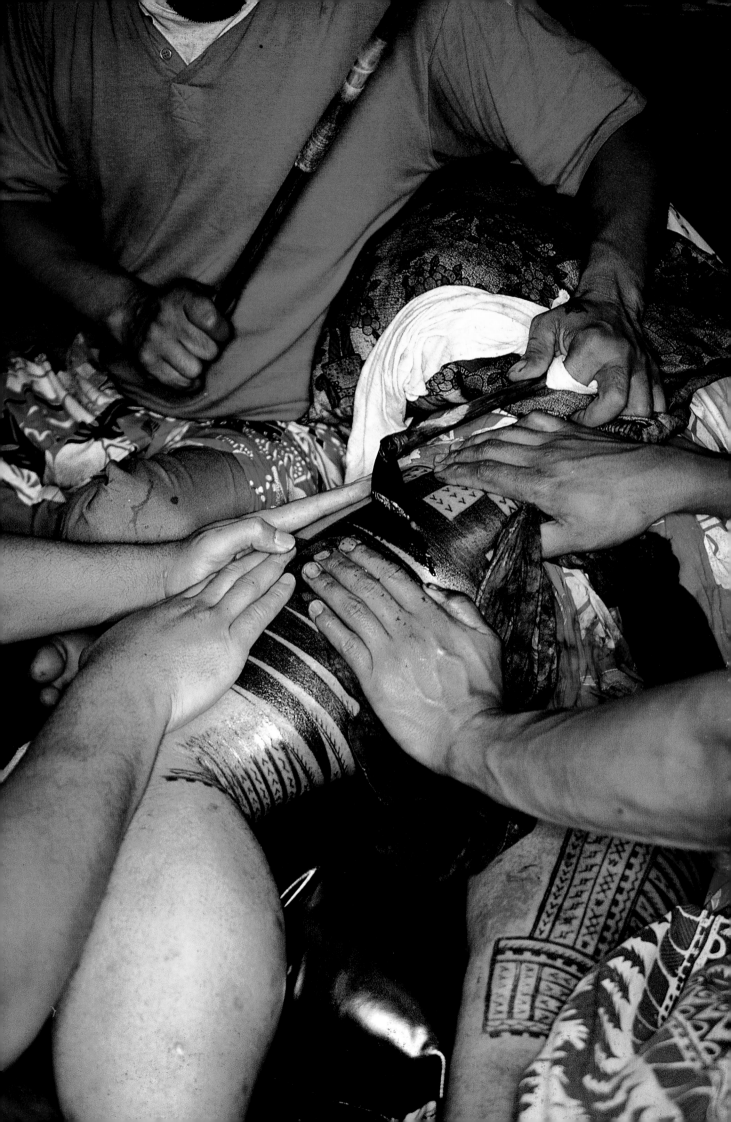

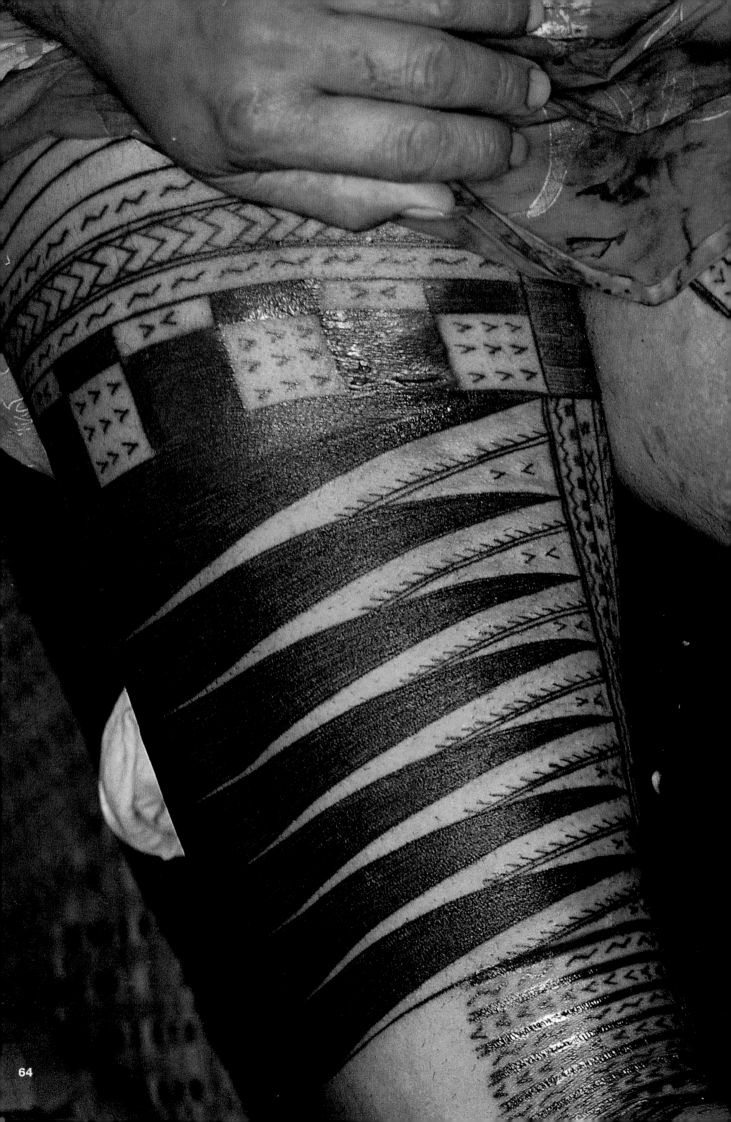

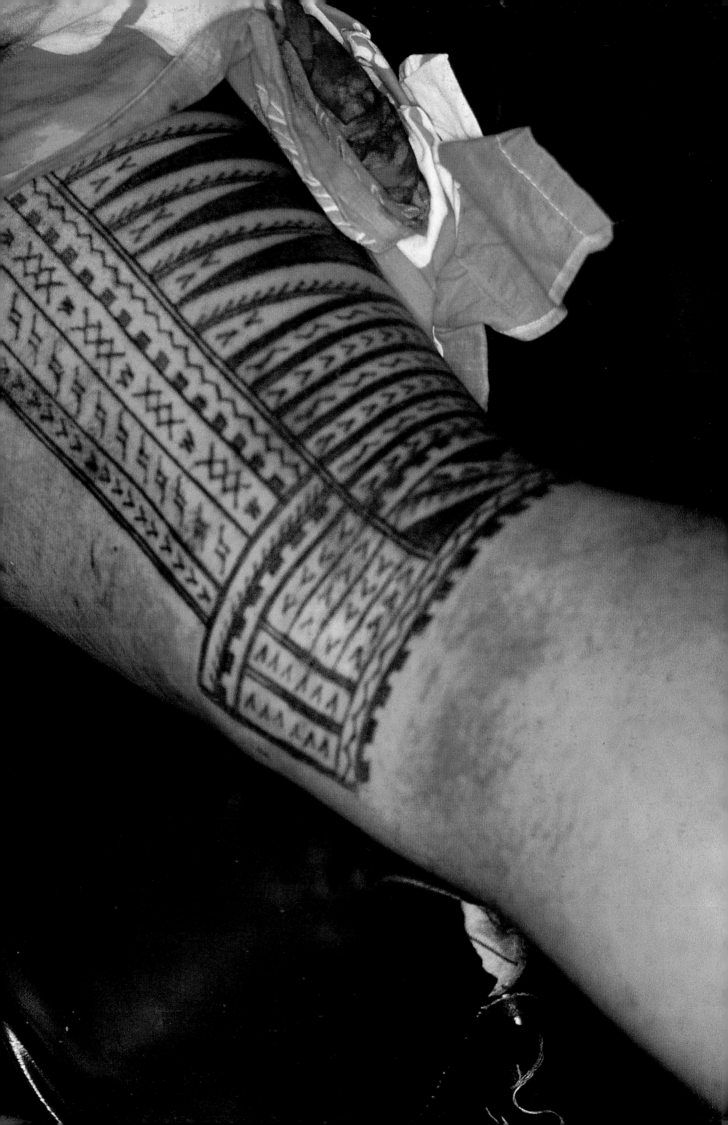

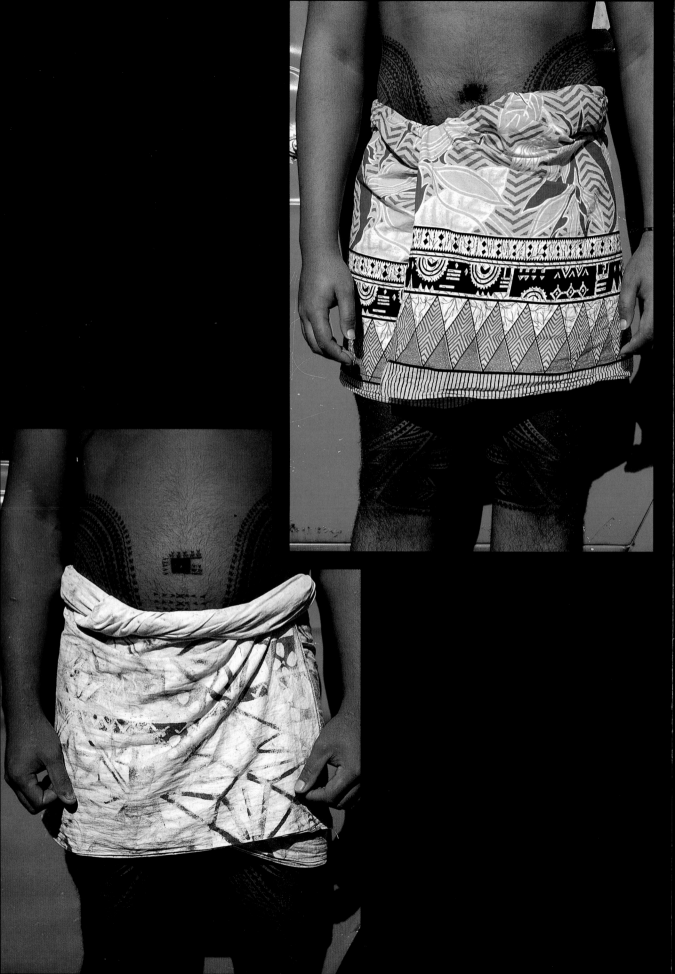

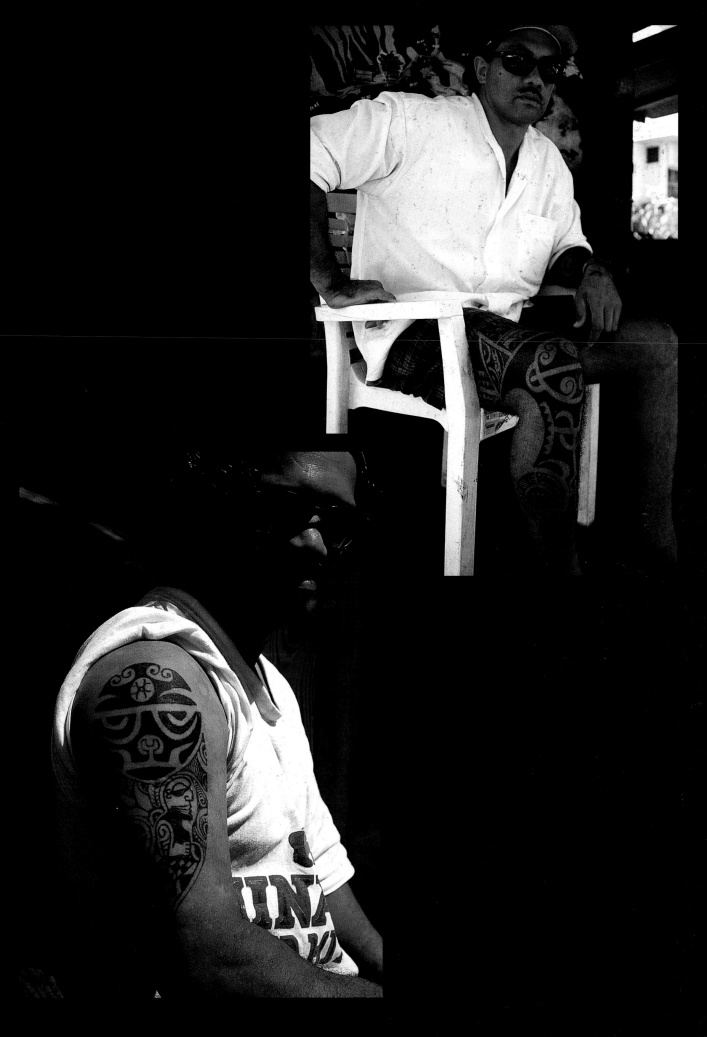

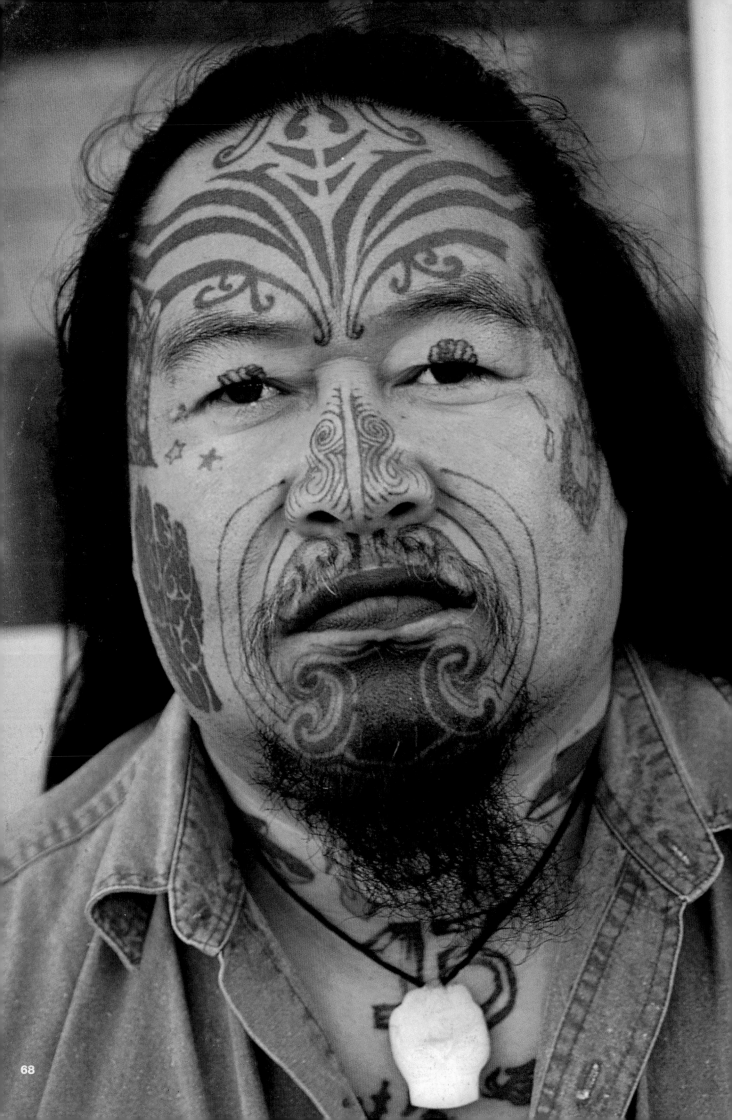

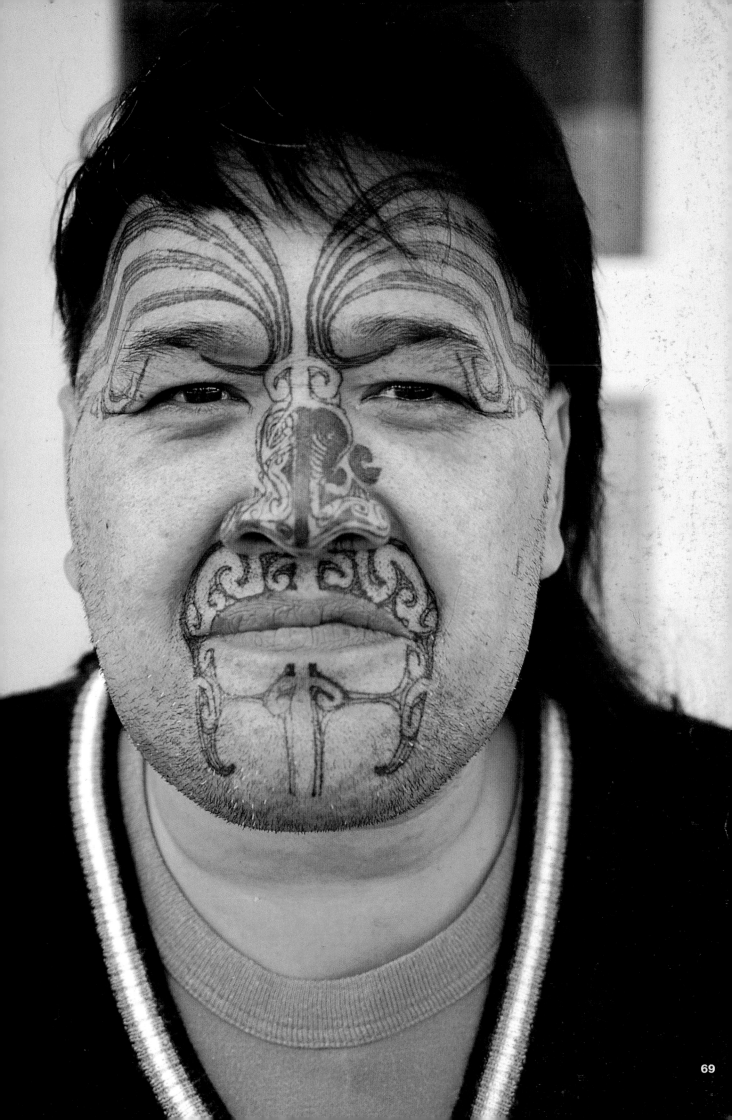

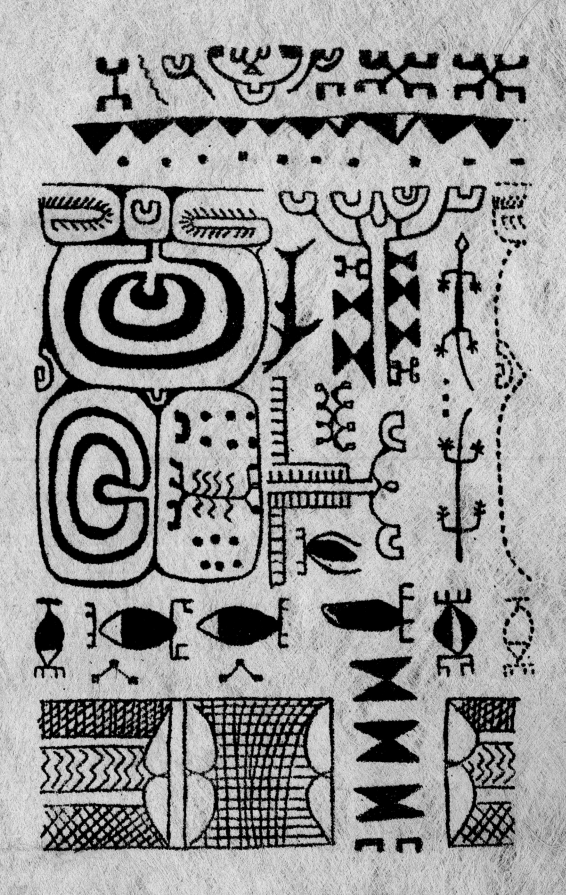

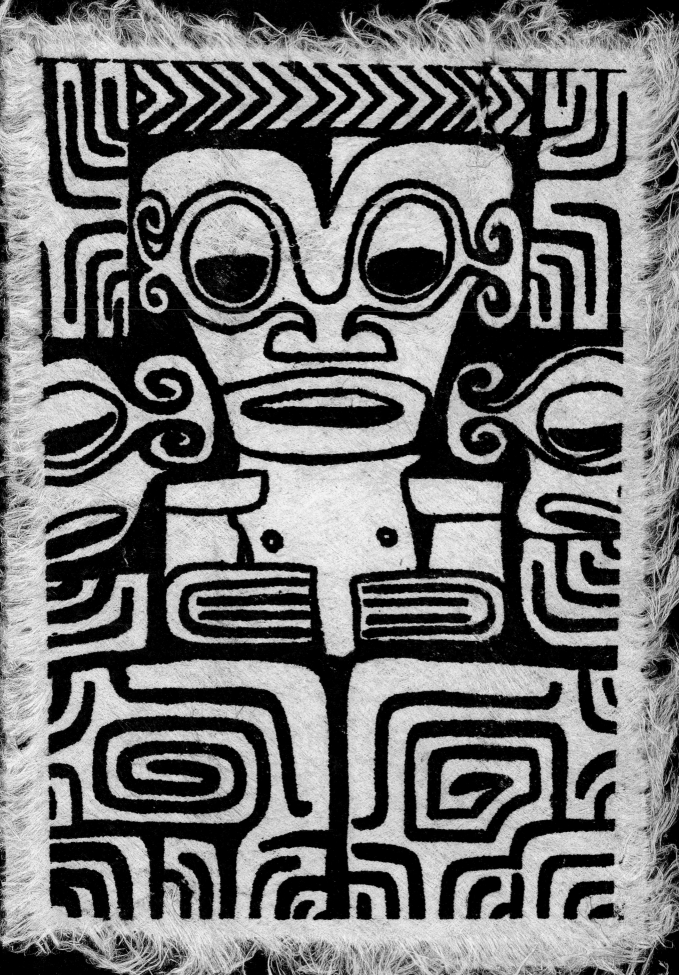

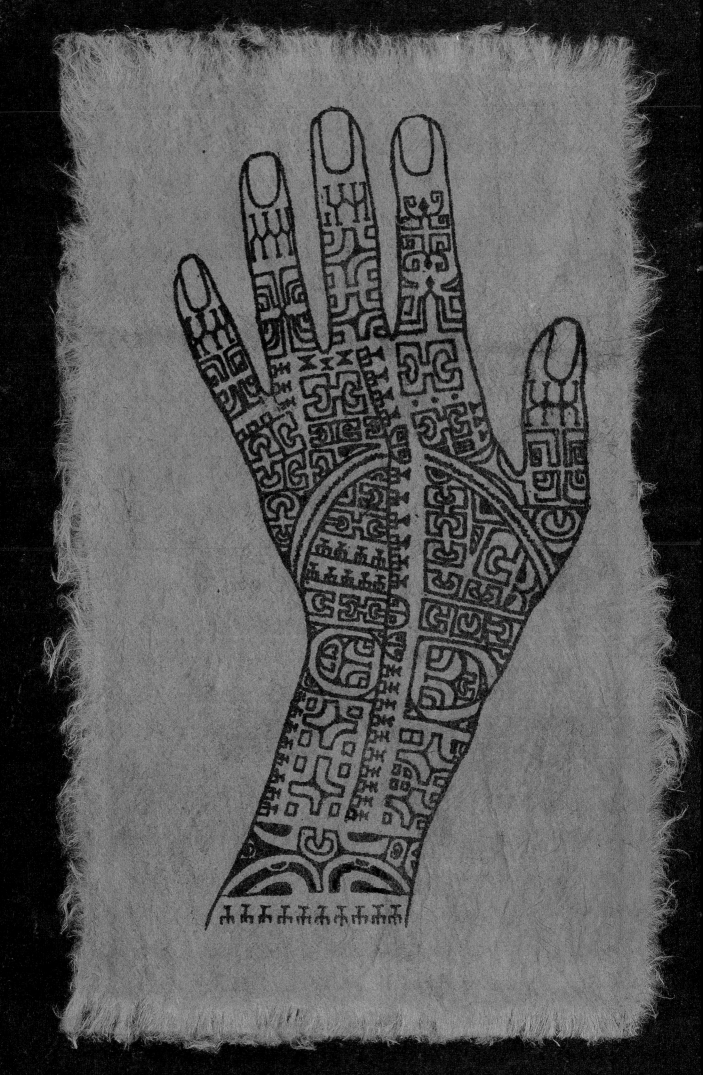

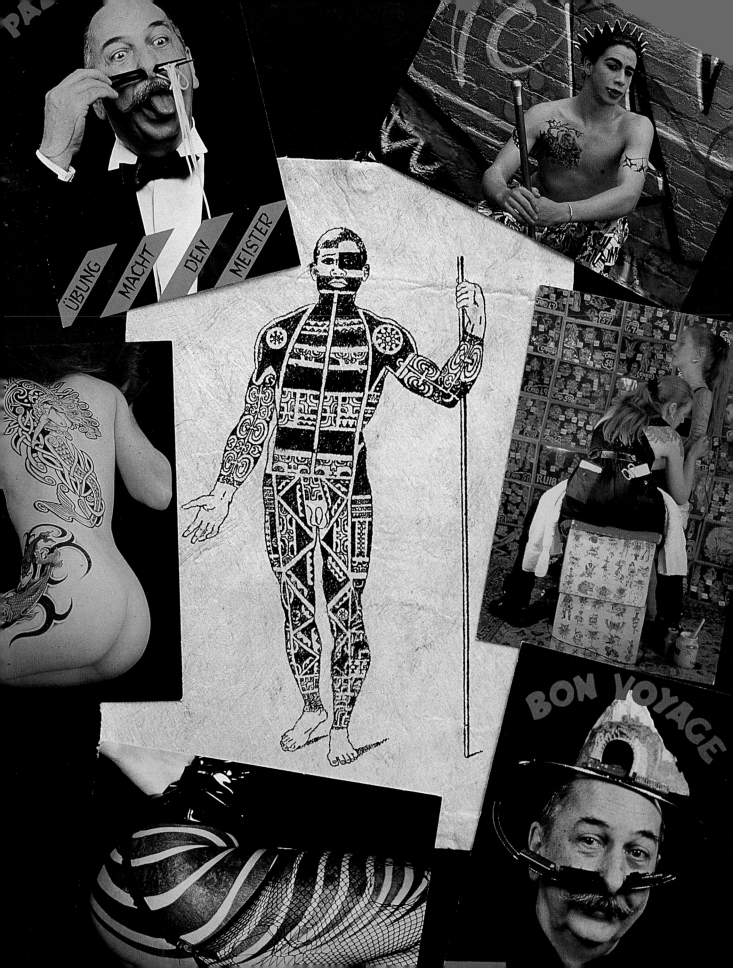

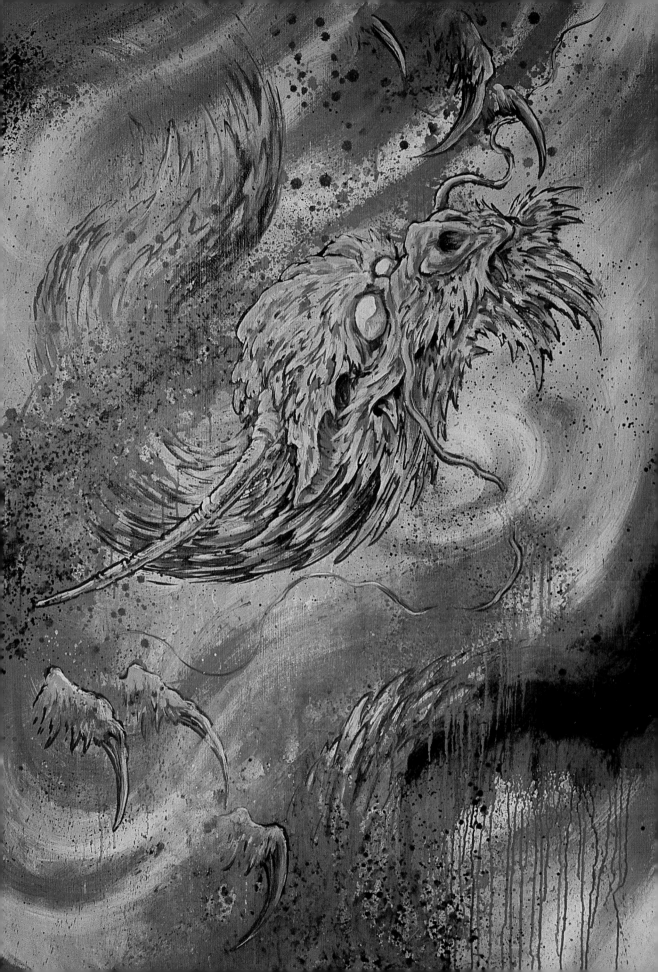

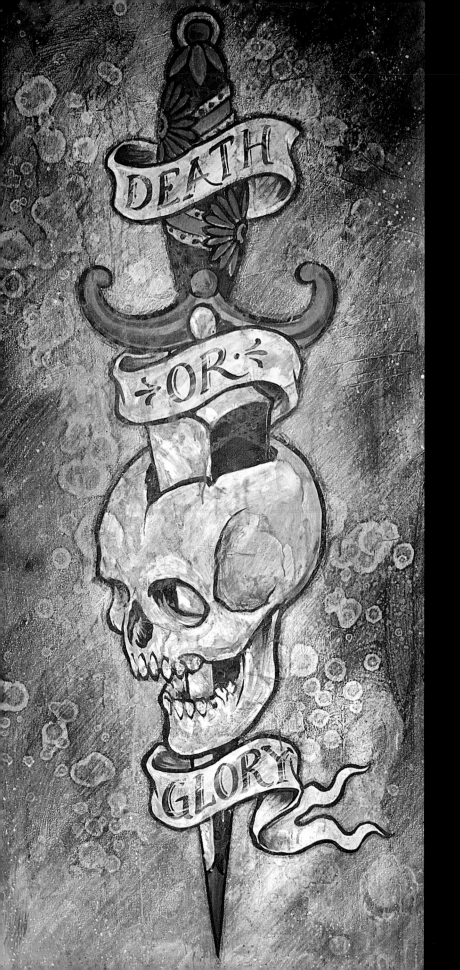

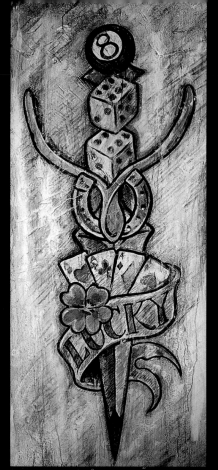

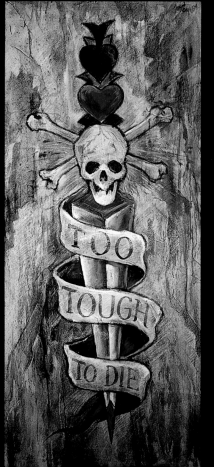

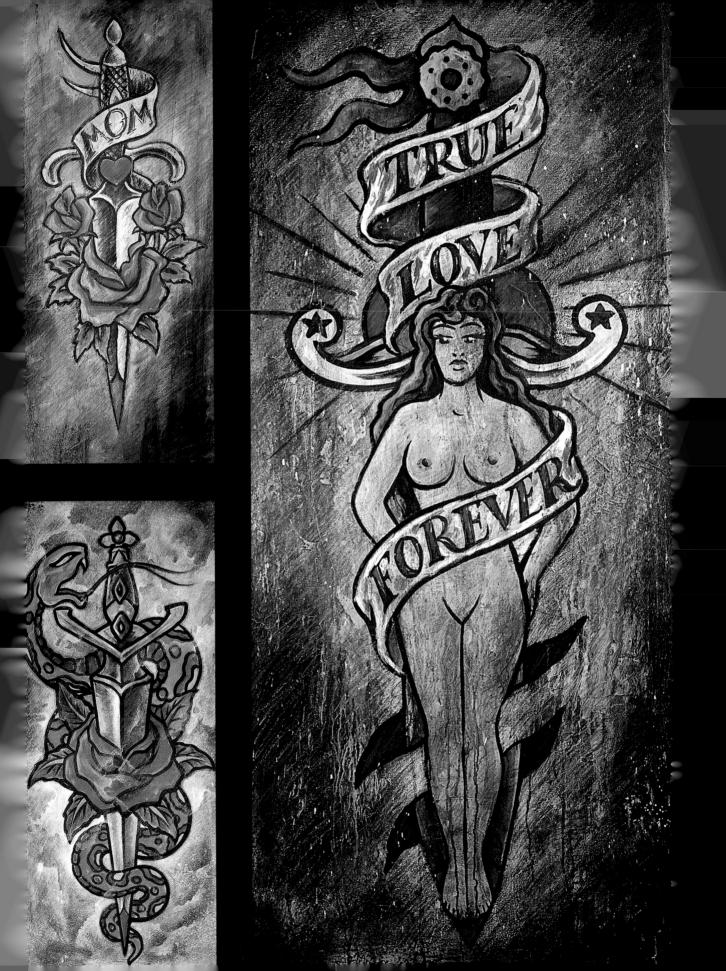

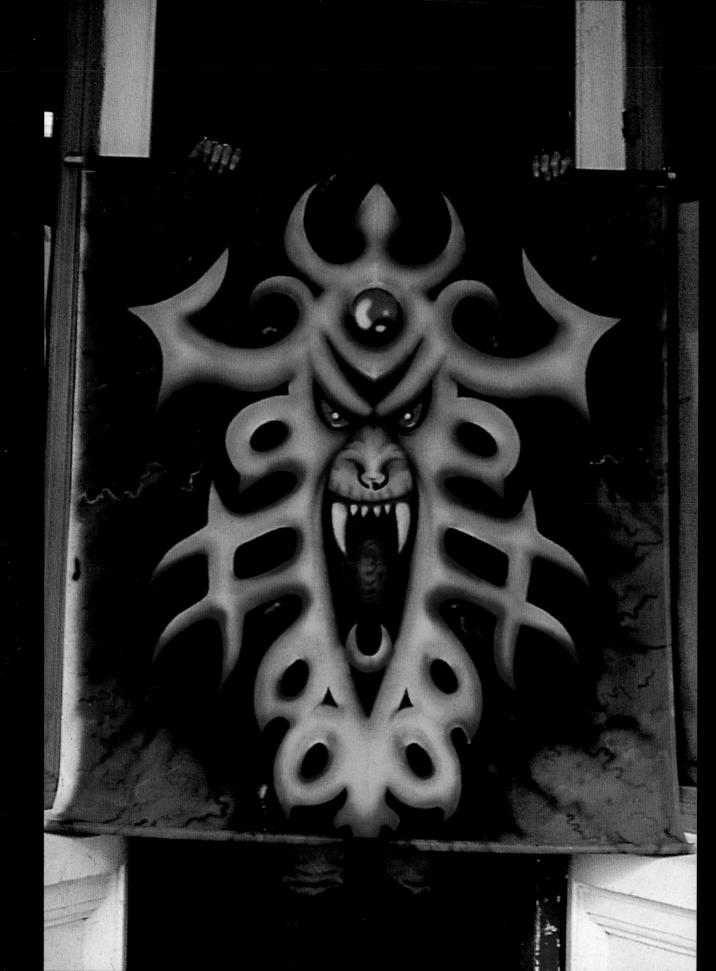

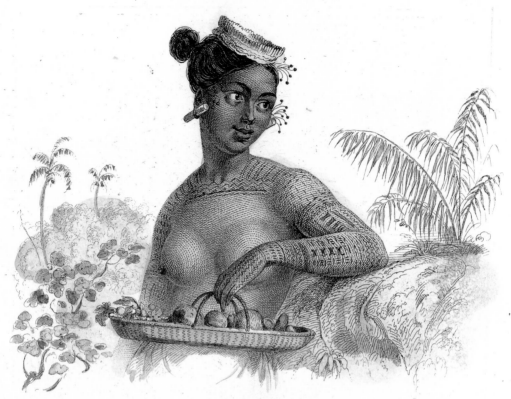

FEMME DE ROTOUMA

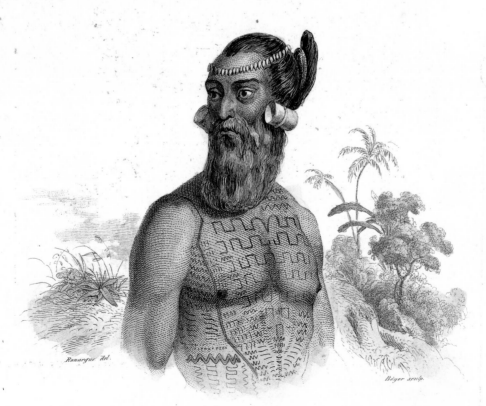

Ranargue del.

Béyer sculp.

INDIGÈNE DES ILES RADAK.

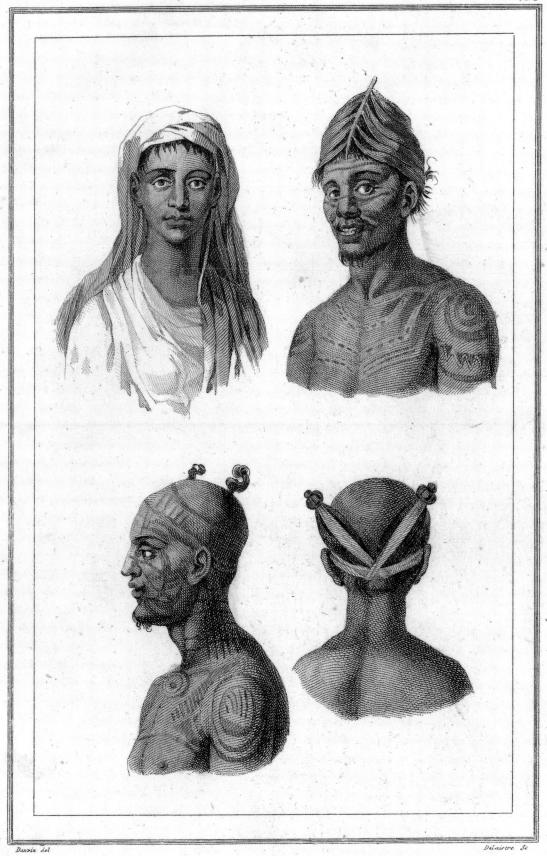

Davin del

Delaistre Sc.

Portraits d'Hommes et Femmes de Nouka-Hiva.

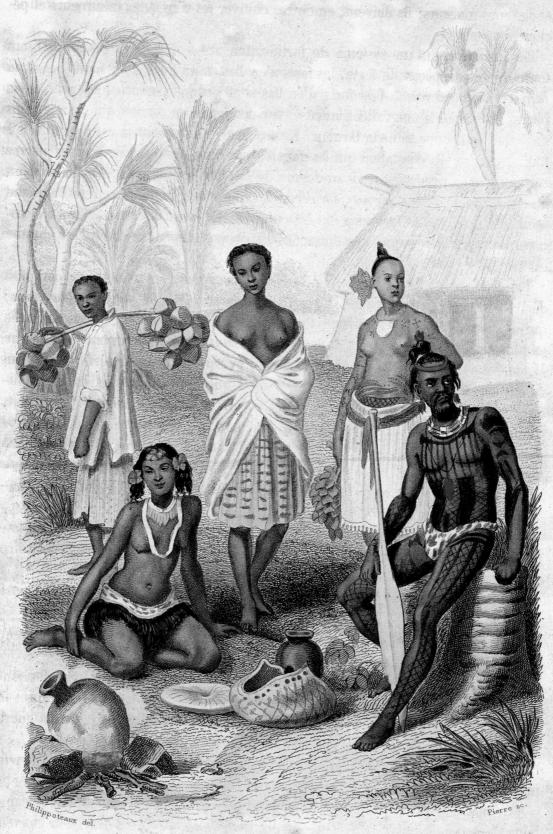

Philippoteaux del. Pierre sc.

Homme de Taïti Femme de l'île Opolou Femme de l'île Routouma
 Jeune fille des îles Viti (Archipel des Navigateurs)
 Naturel des îles Iros
 (Archip. des Carolines)

OCÉANIE

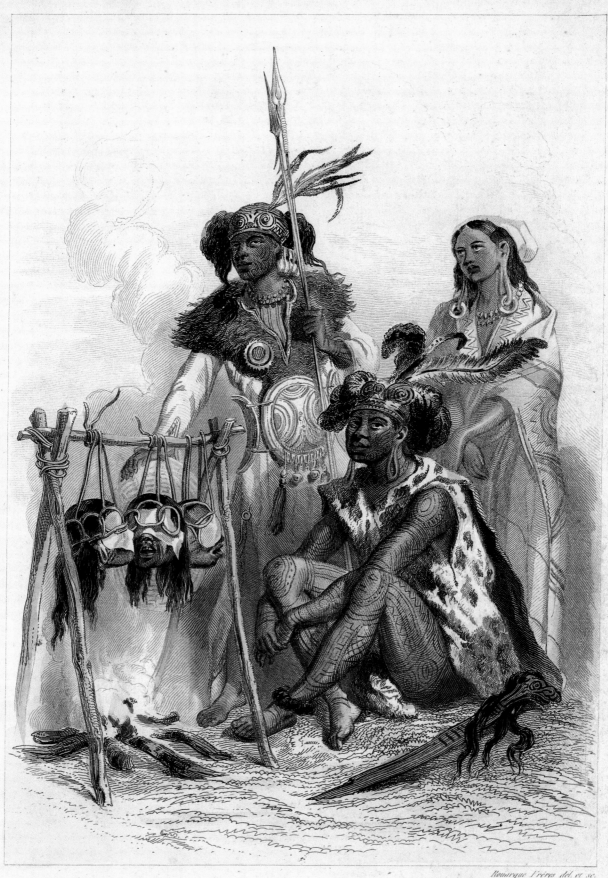

Rouargue Frères del. et sc.

GUERRIERS ET FEMME DE BORNÉO.

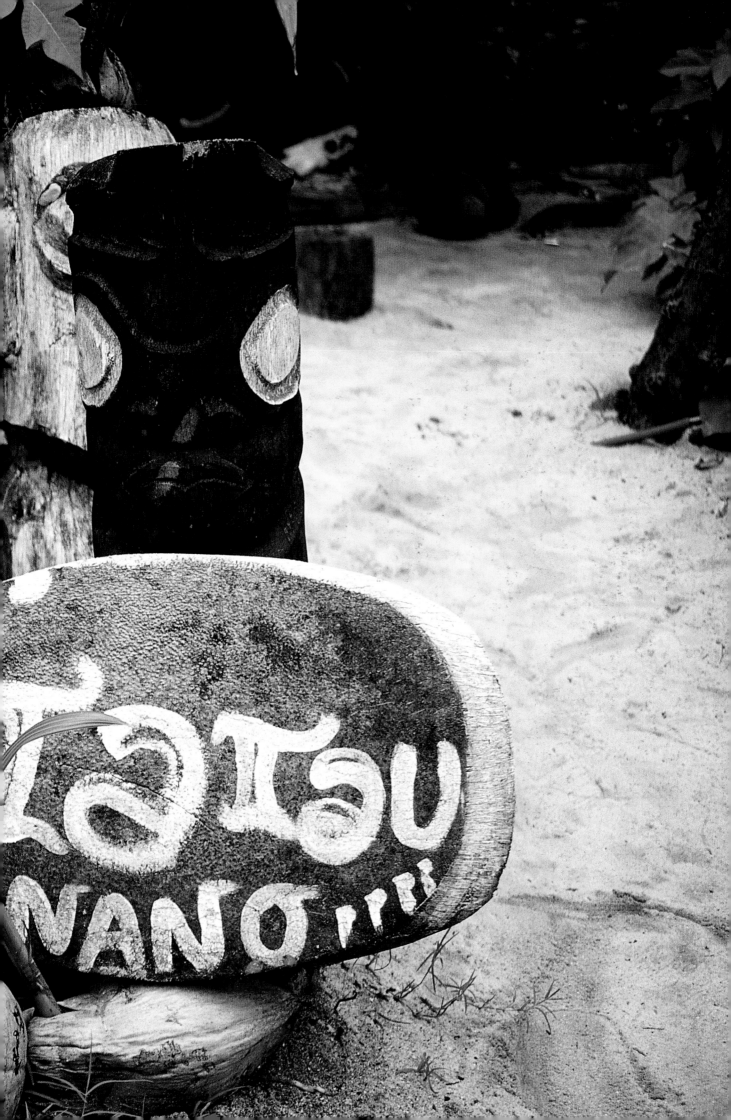

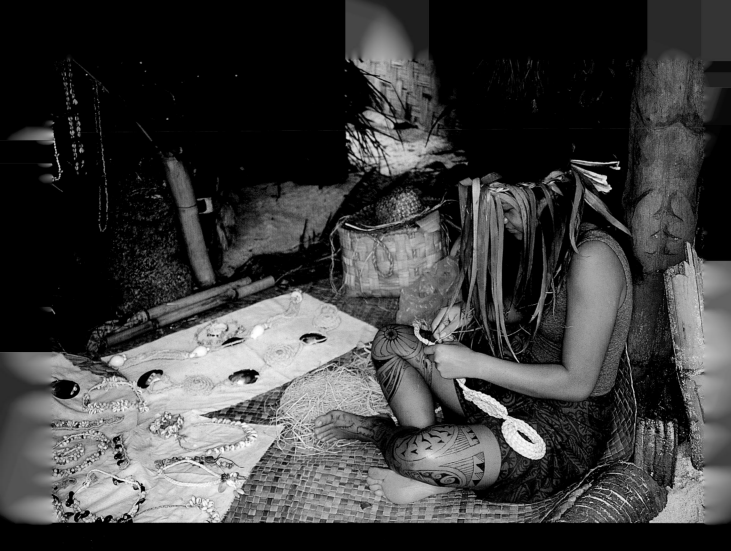

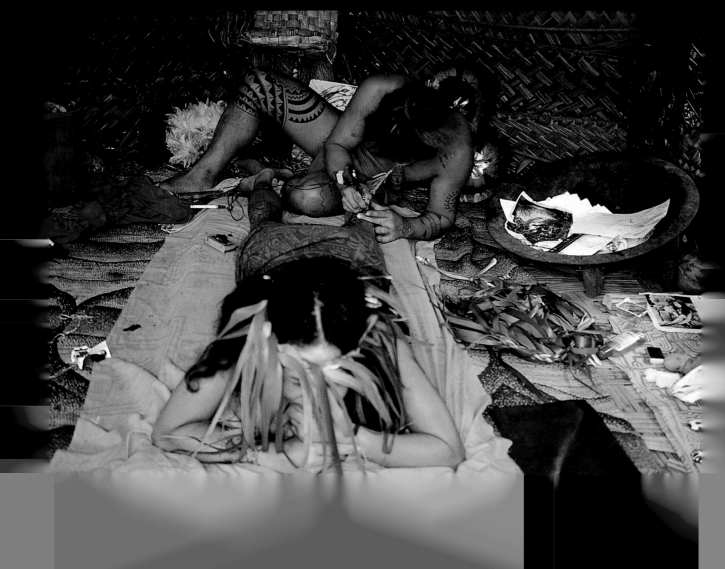

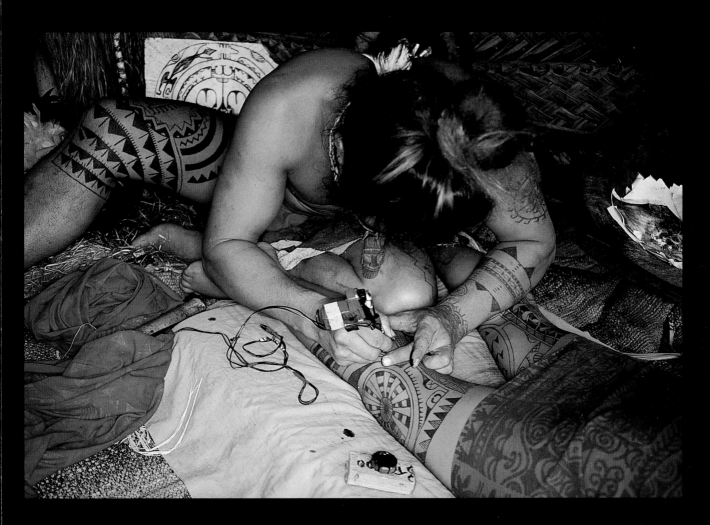

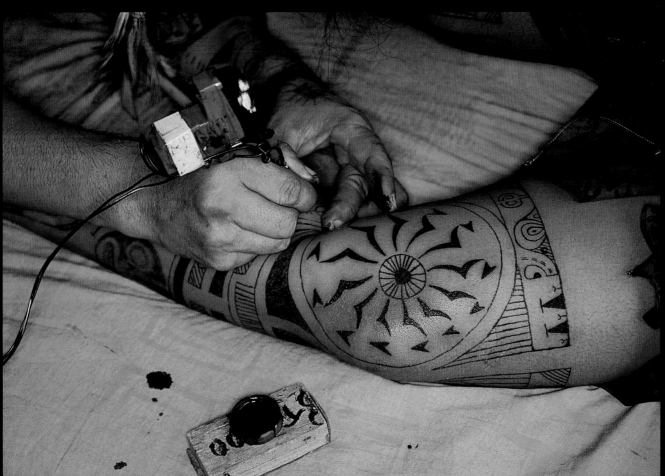

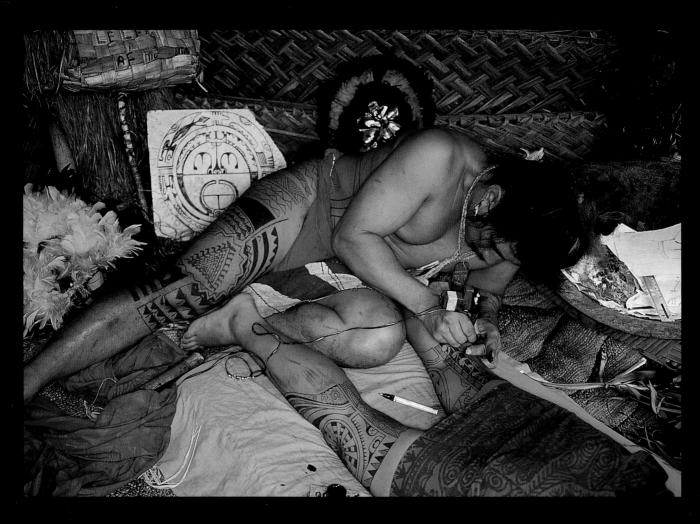
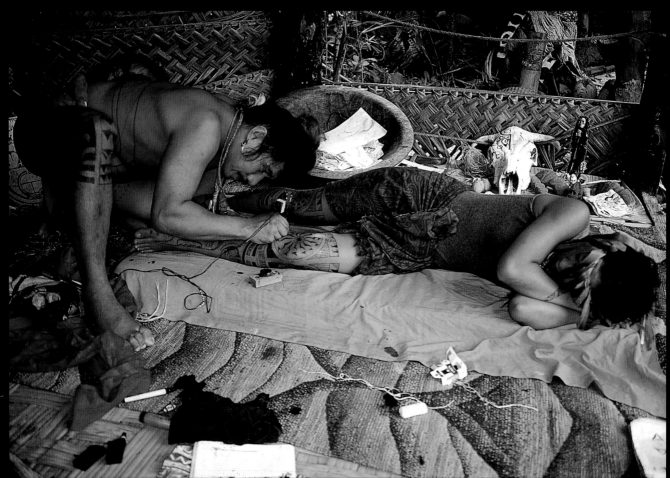

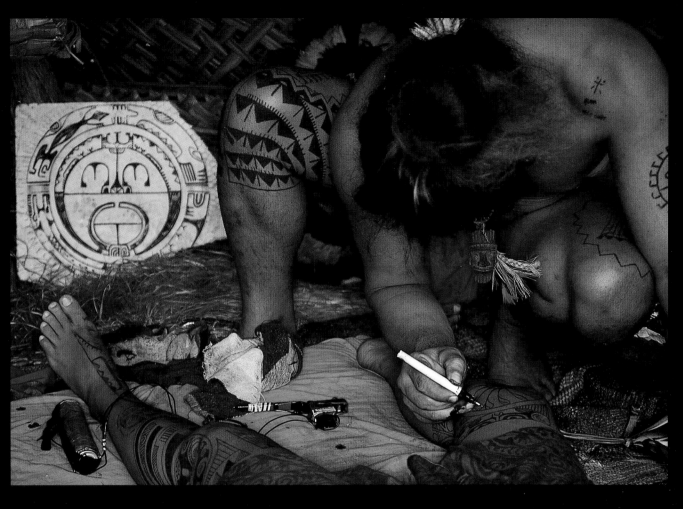

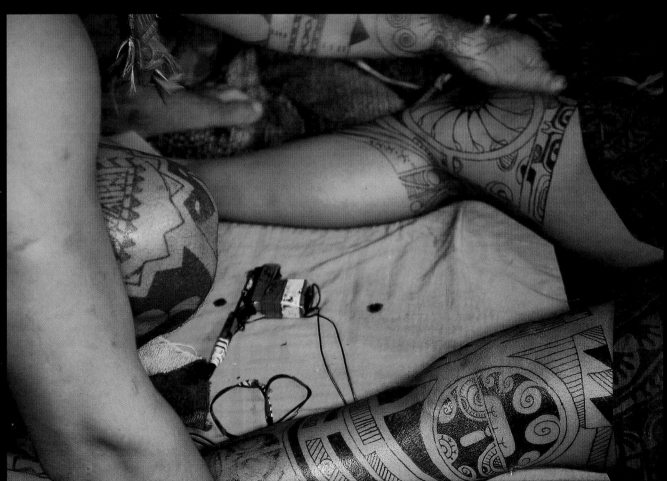

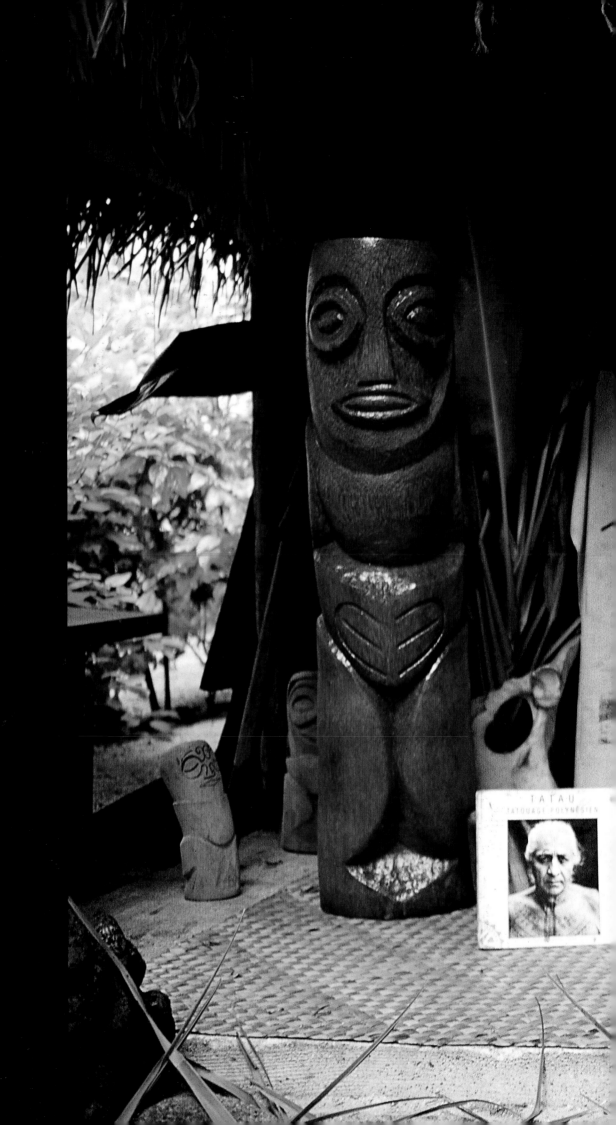

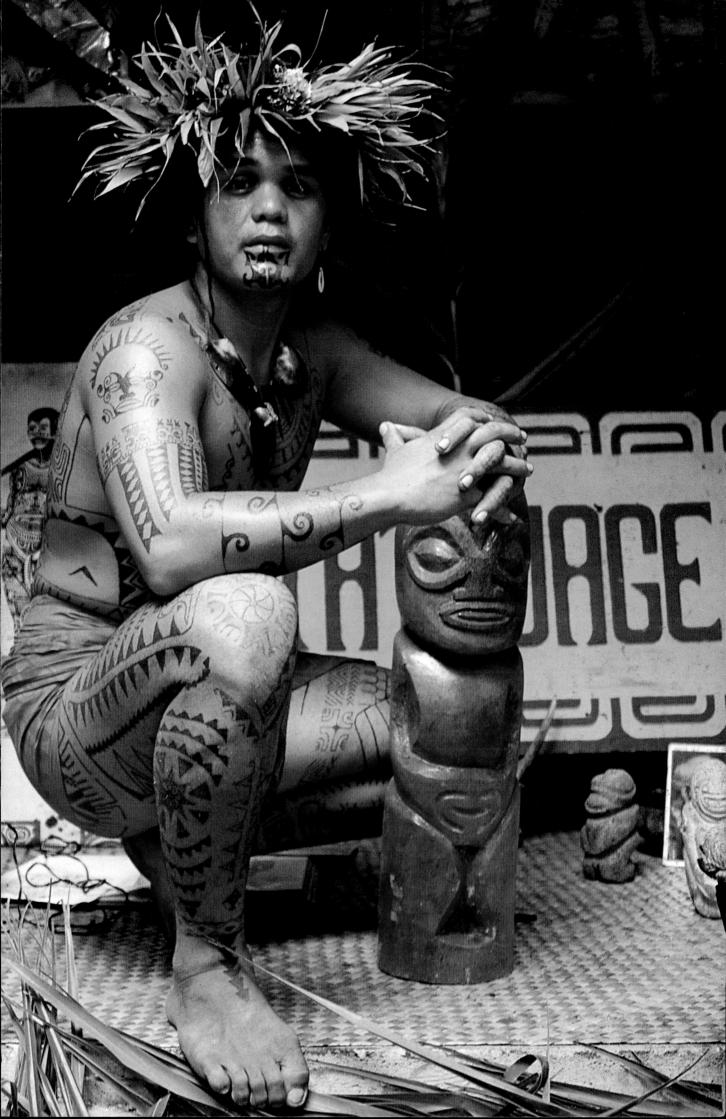

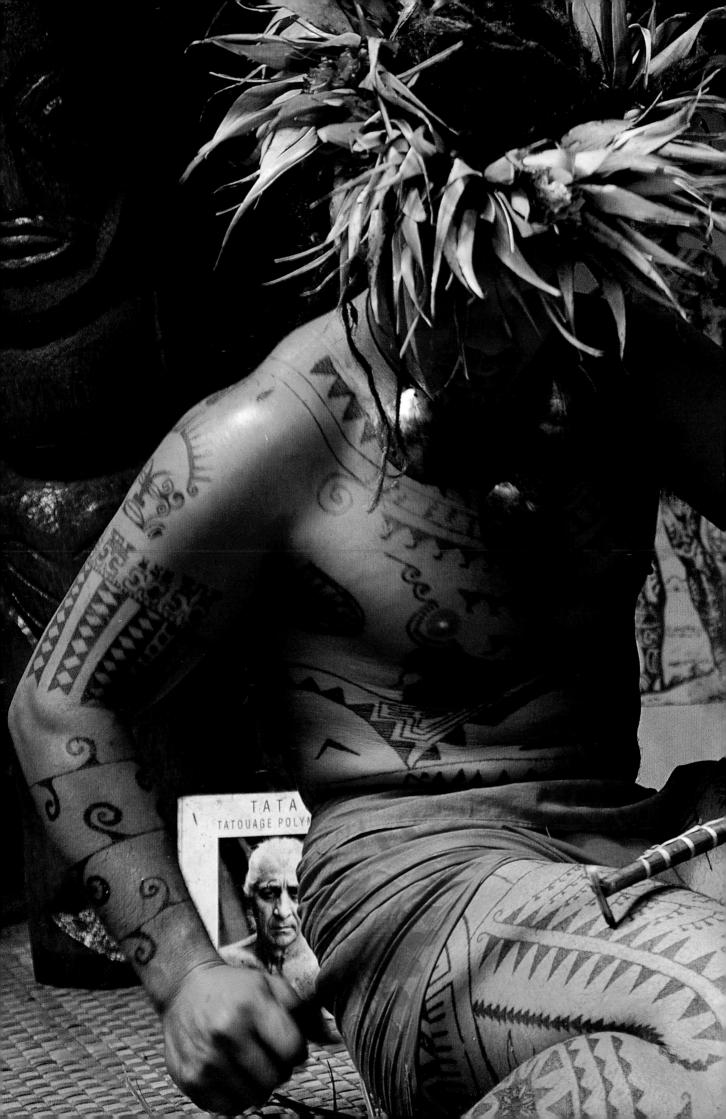

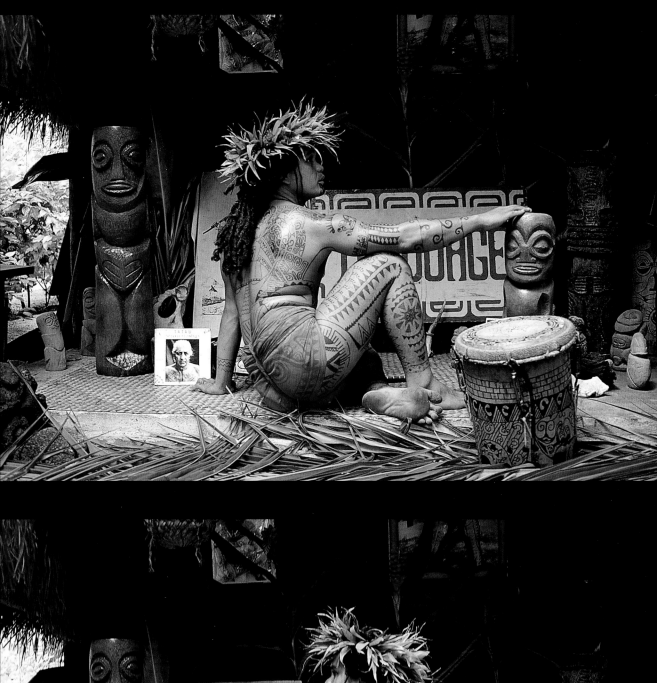
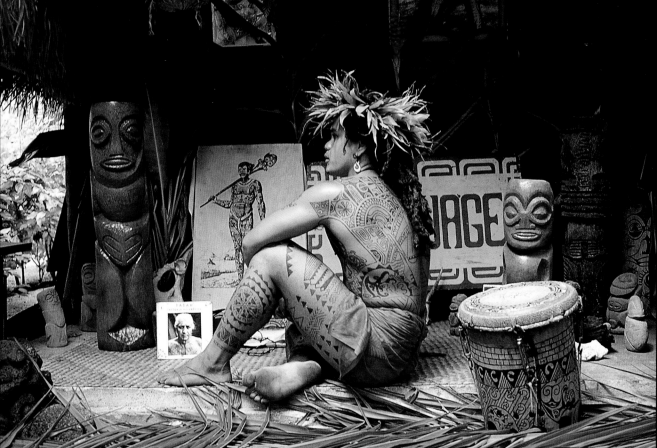

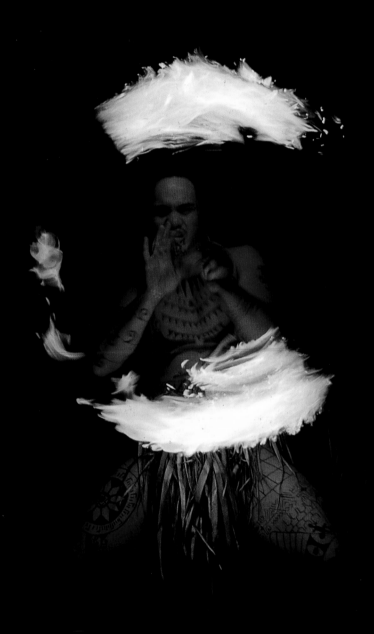

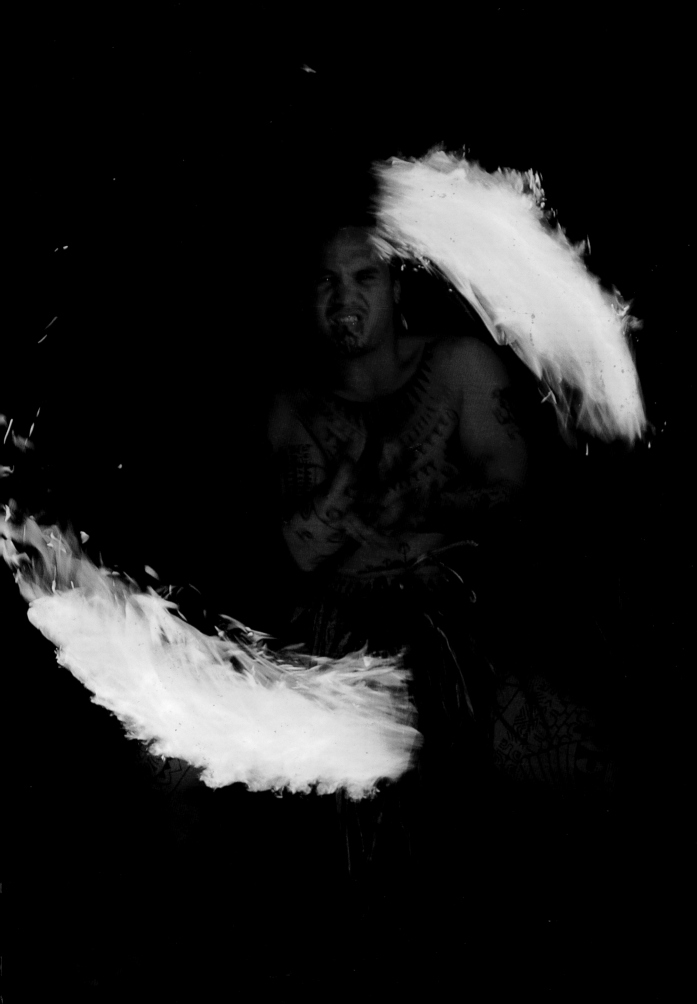

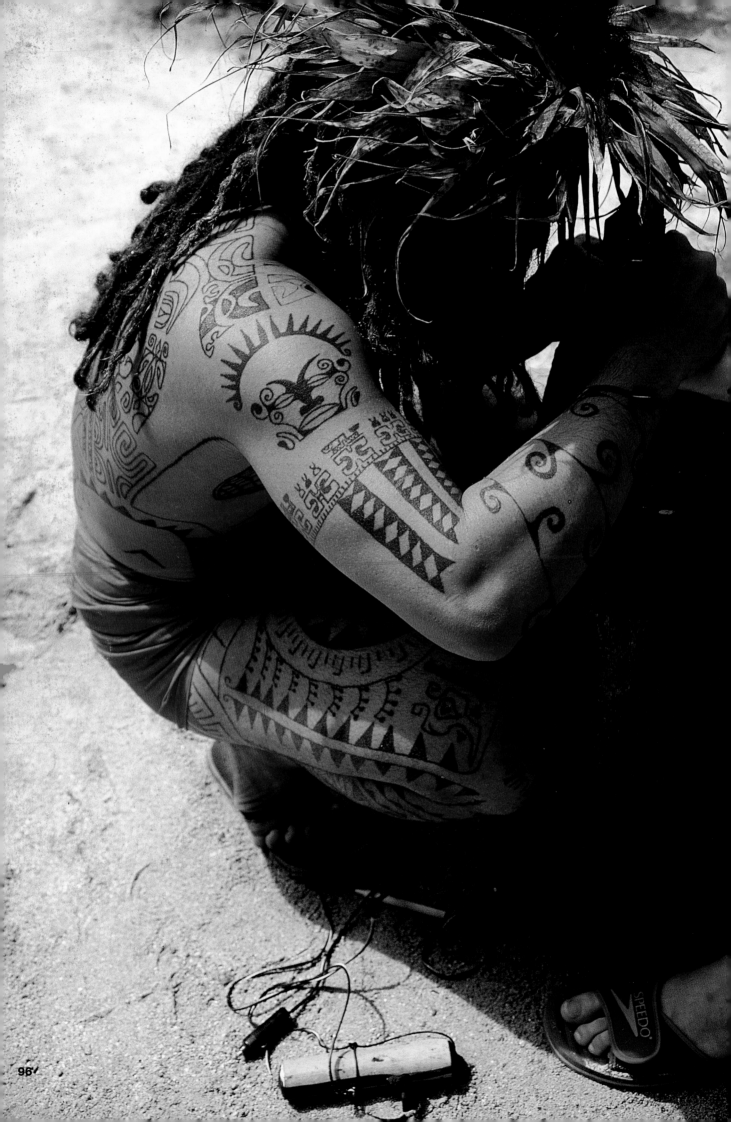

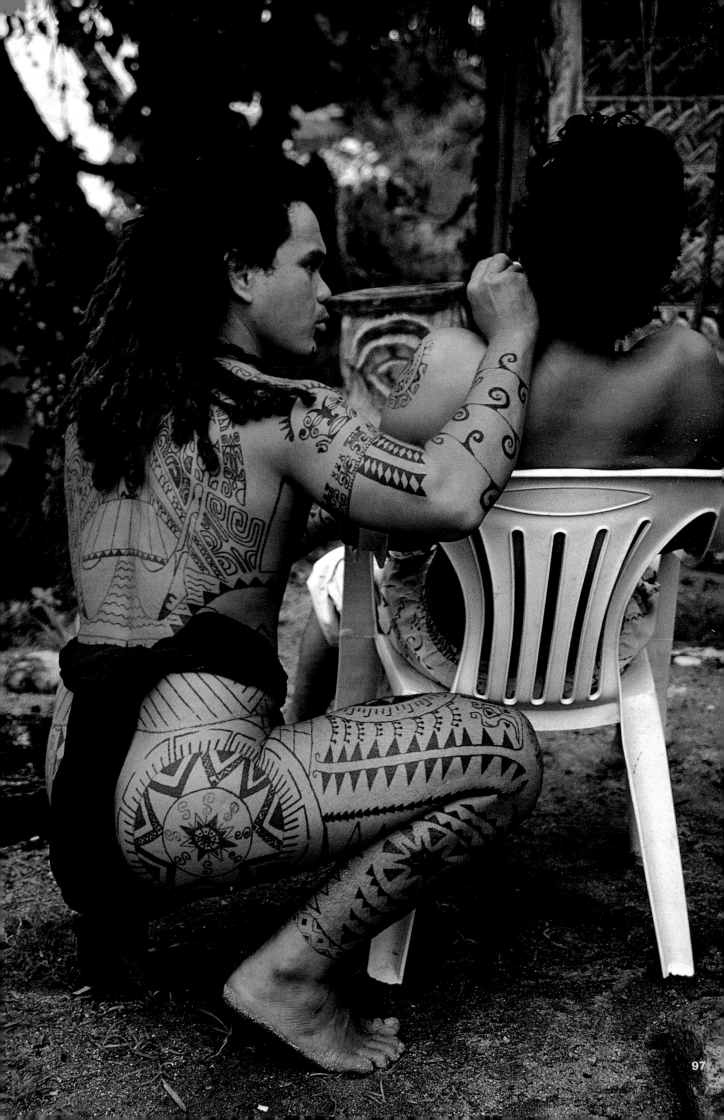

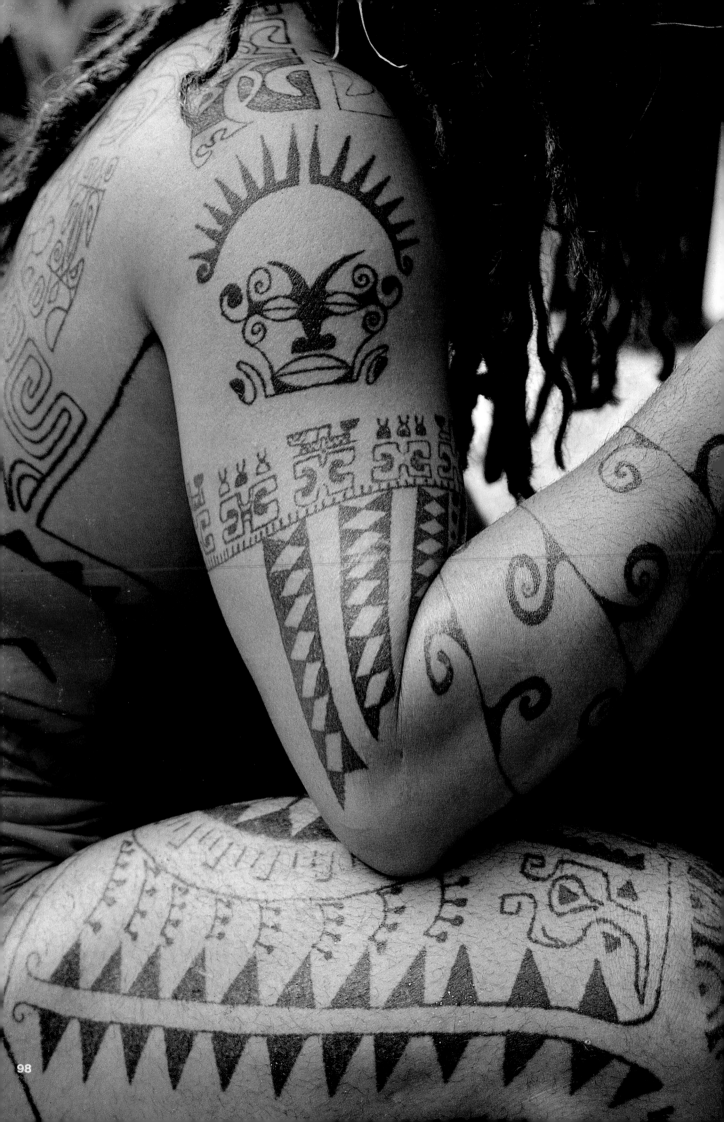

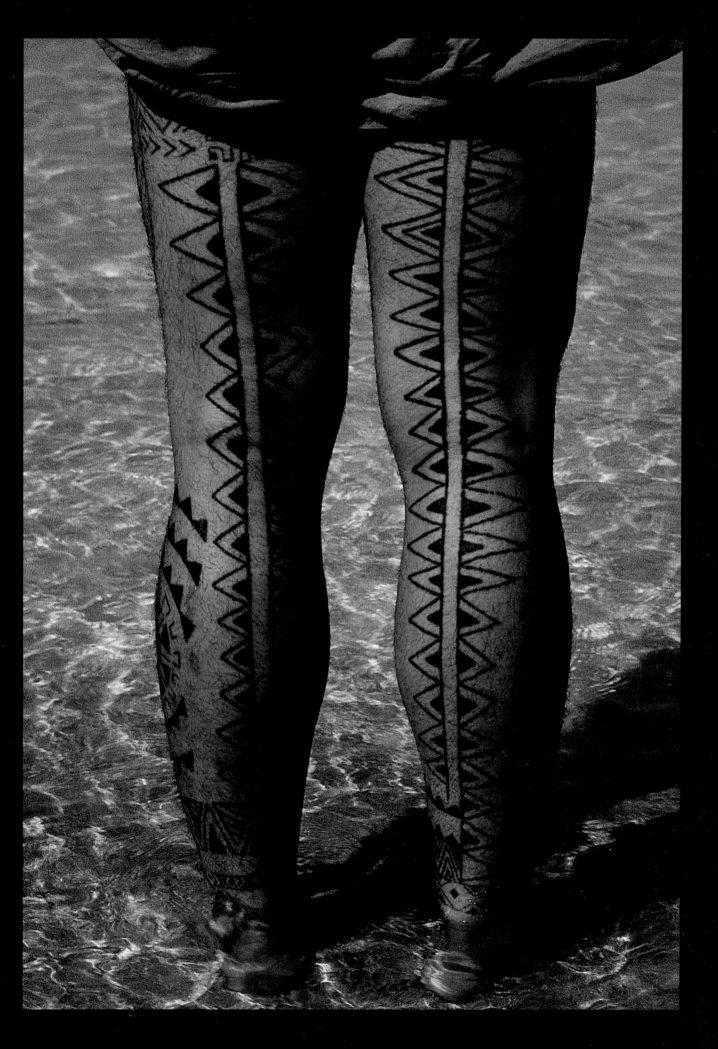

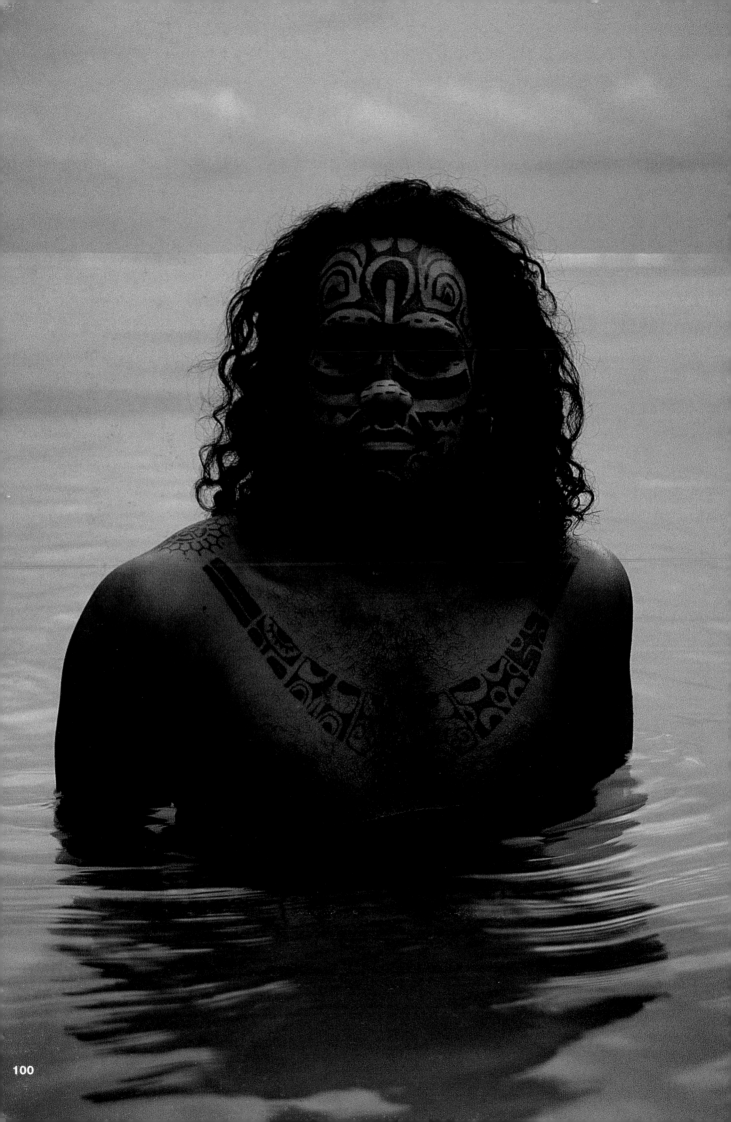

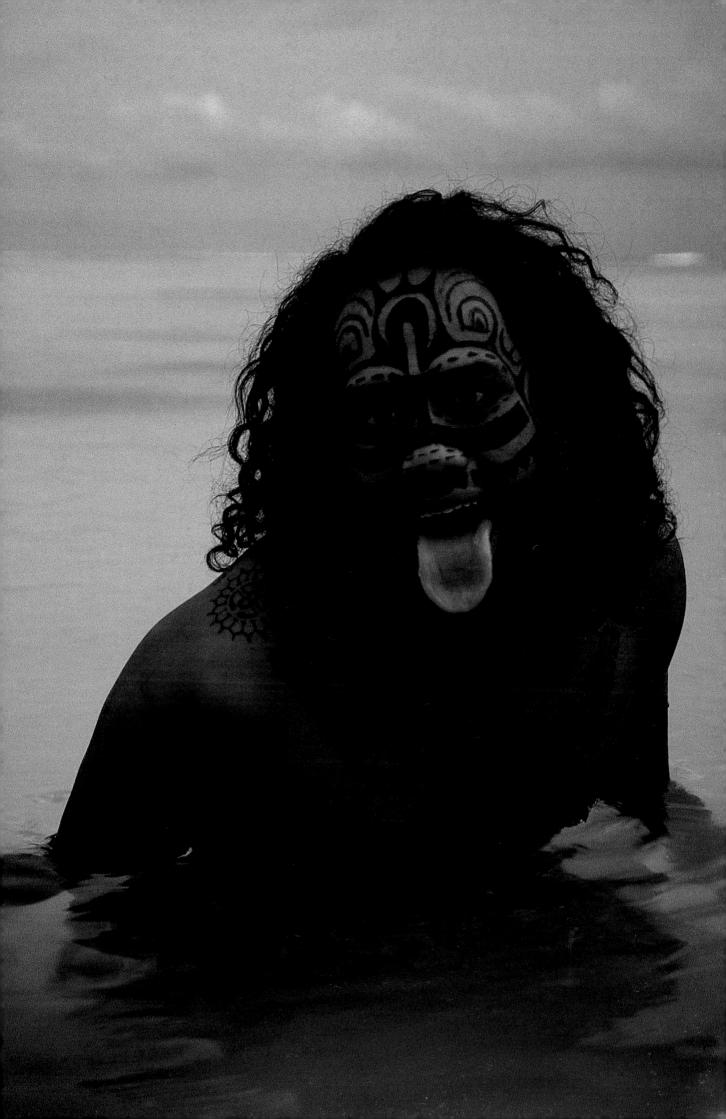

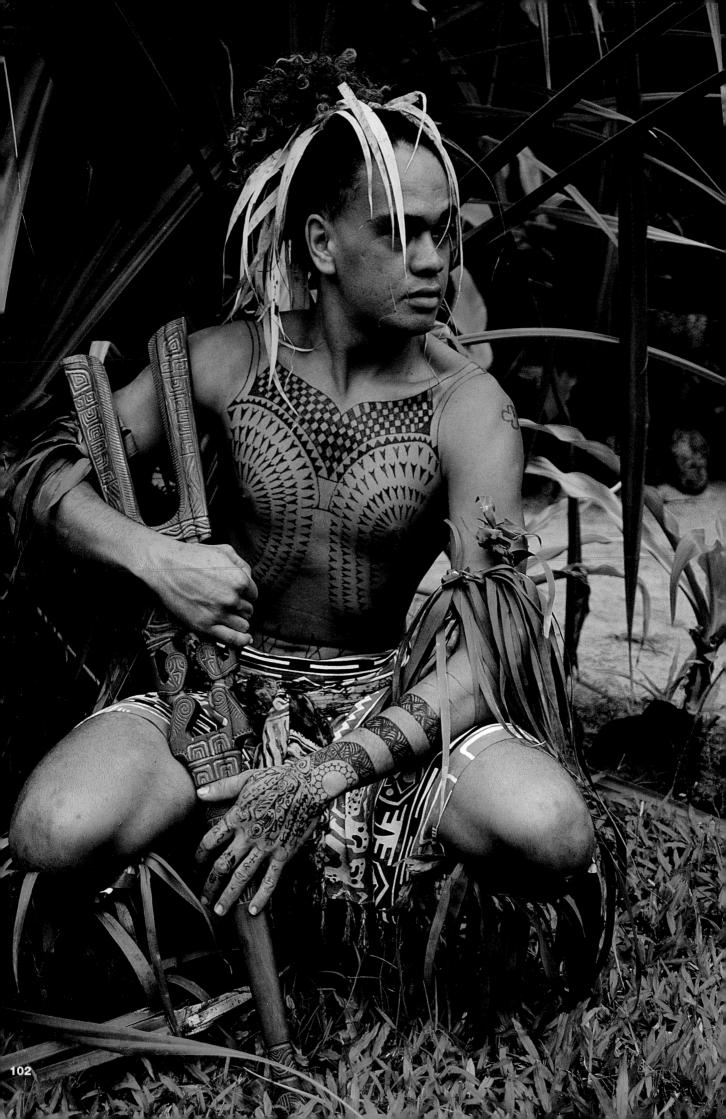

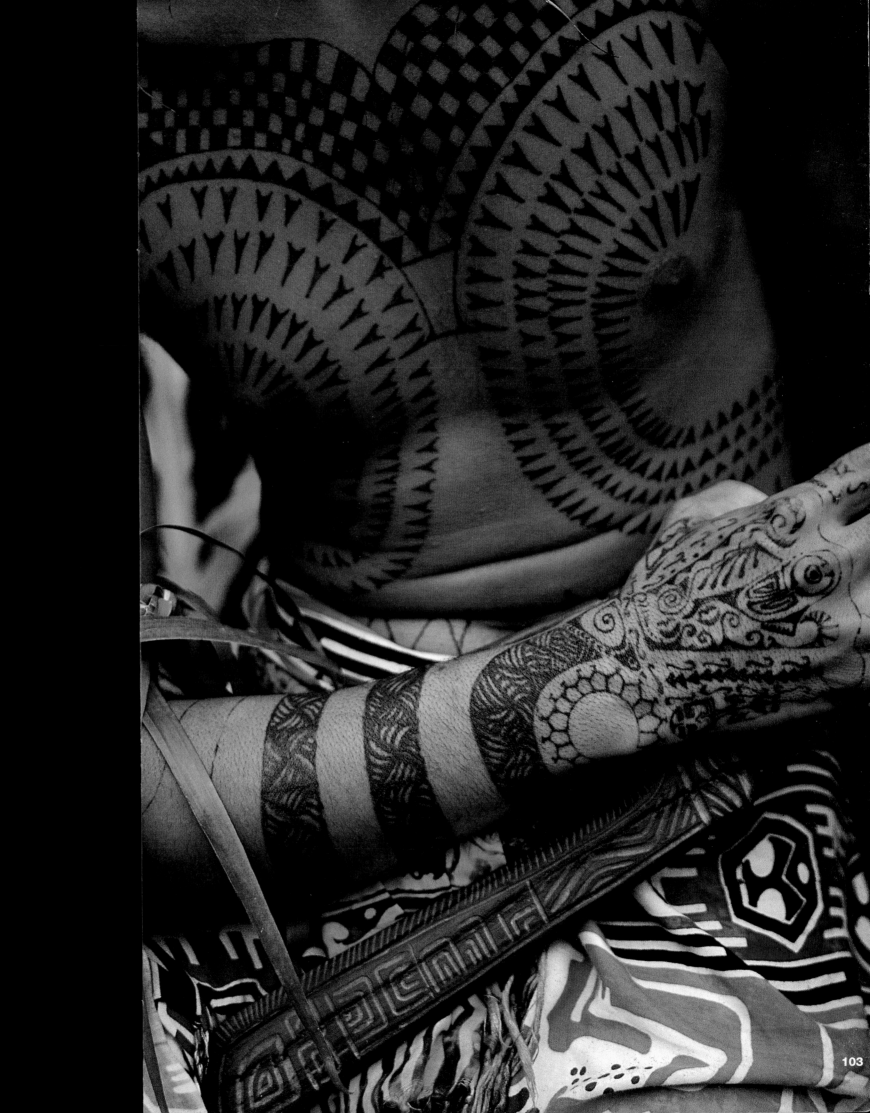

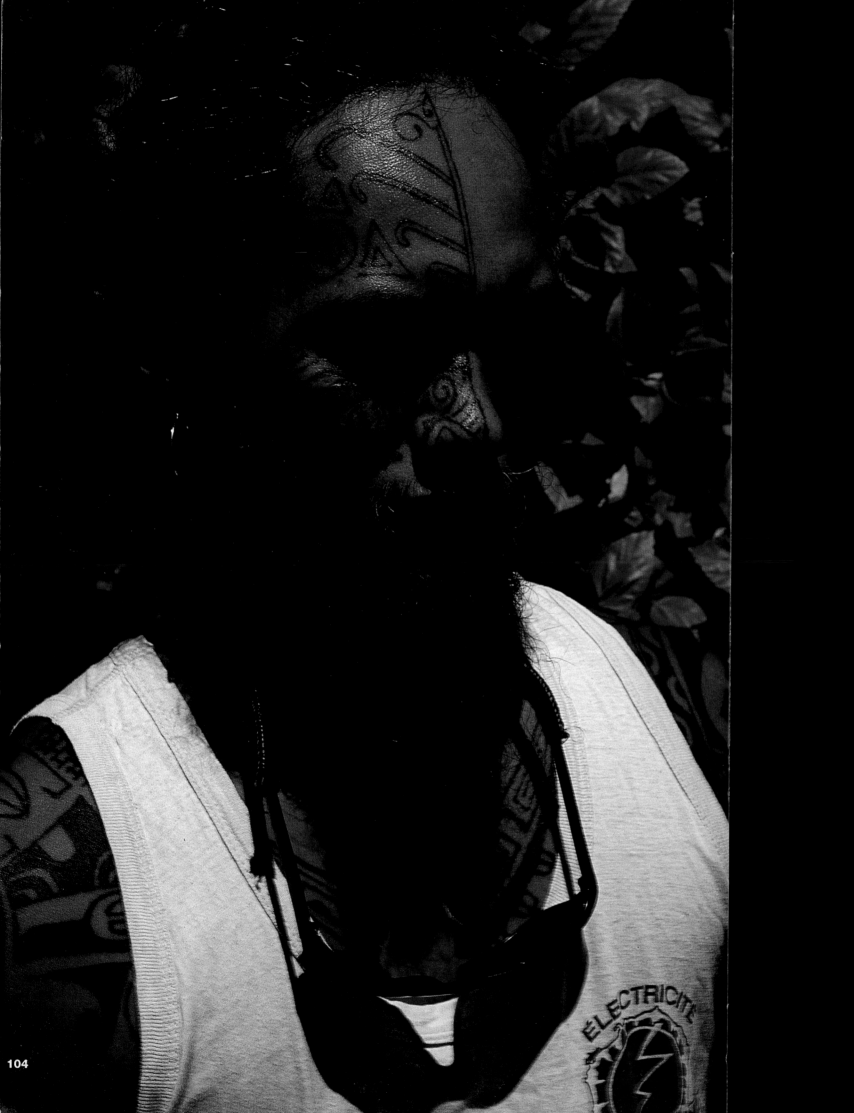

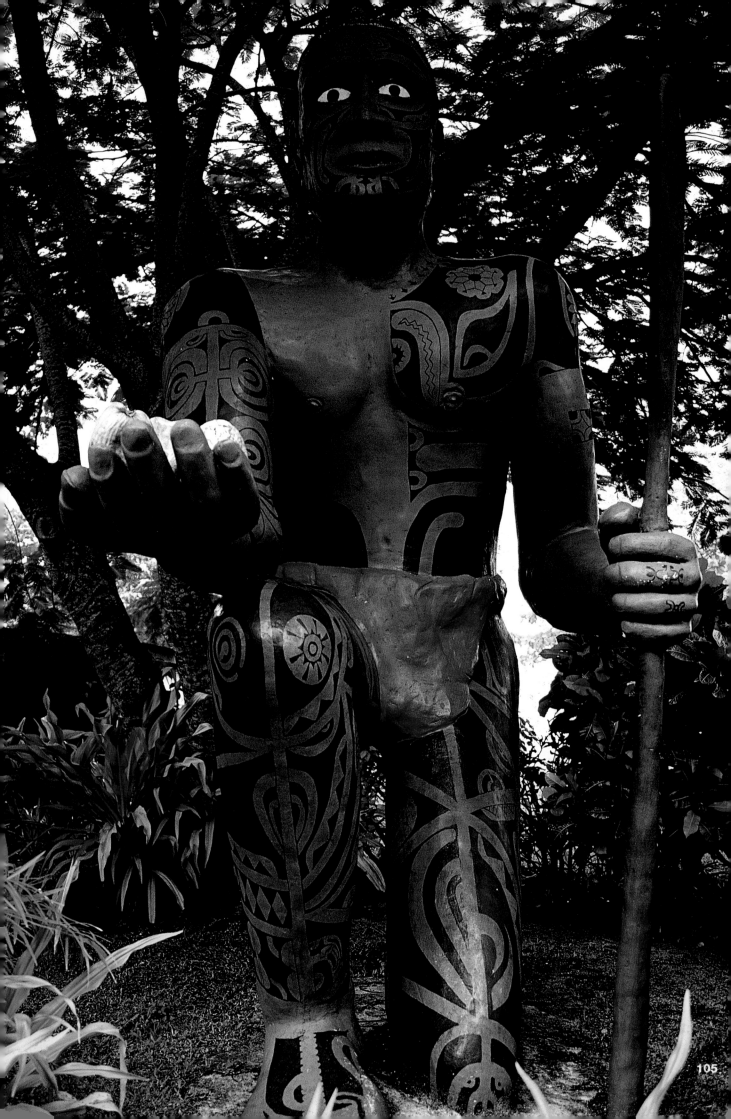

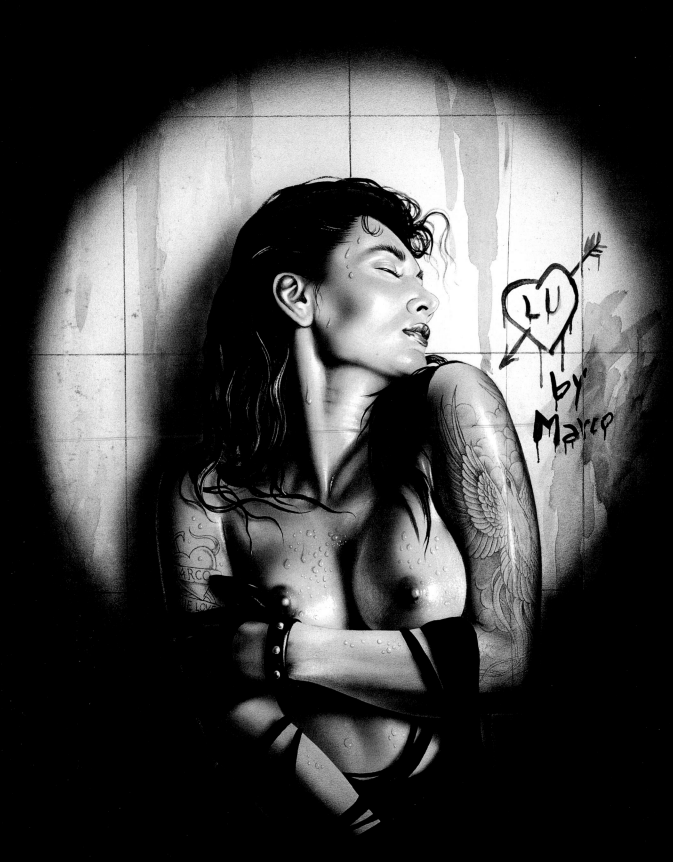

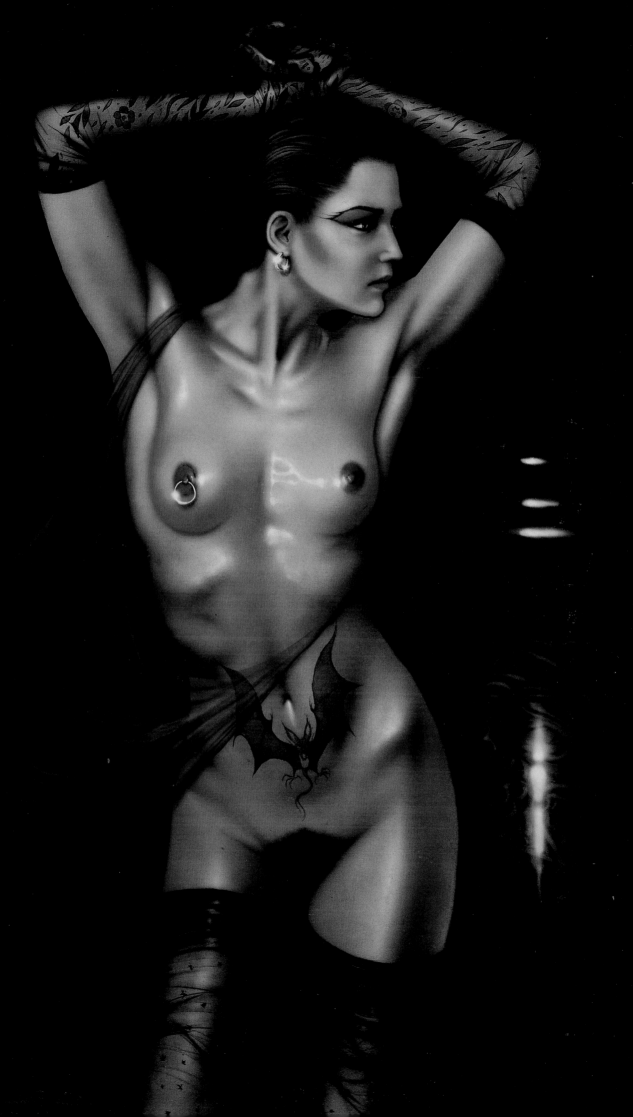

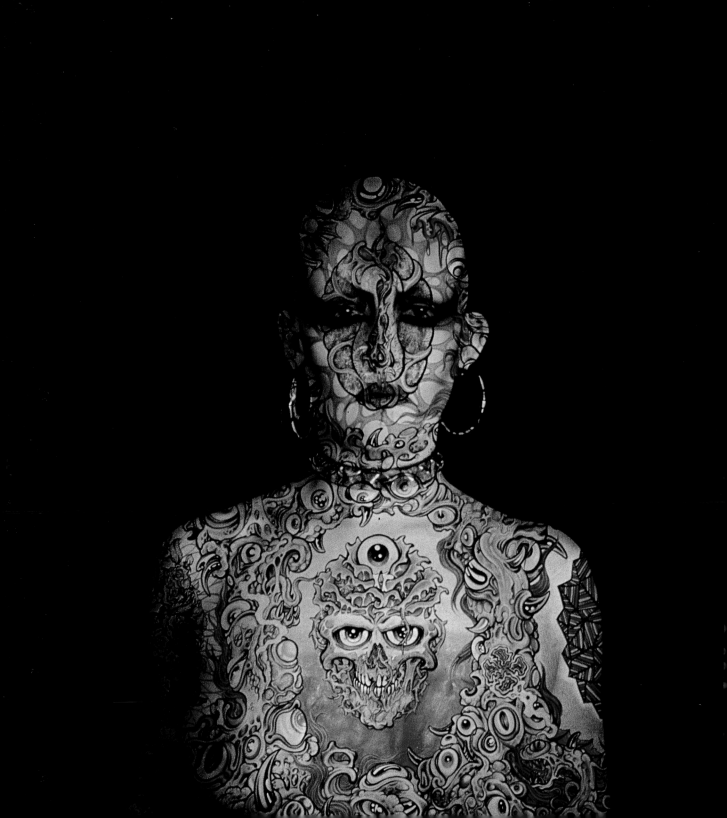

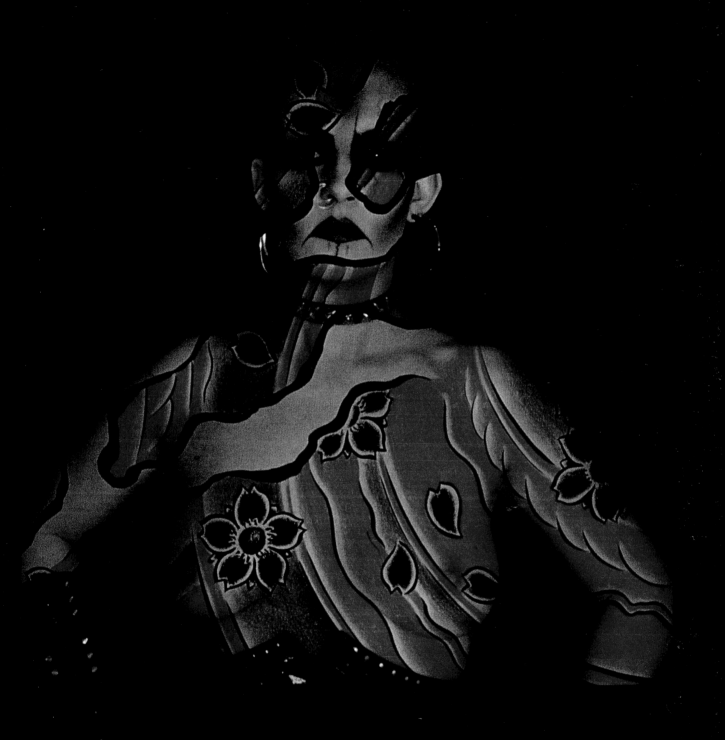

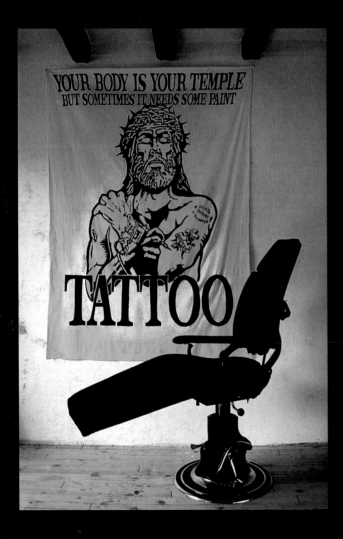

YOUR BODY IS YOUR TEMPLE
BUT SOMETIMES IT NEEDS SOME PAINT

TATTOO

Page 79. Tattoo clothing Boutiques are located in Switzerland:

Tat-Too, Rue Haldimand 13, 1002 Lausanne.
Tel: 021 323 4692

Rue du Centre 8 1800 Vevey. Tel: 021 992 8425.

Les Grillons 3963 Crans. Tel. 027 41 5816.

C.comm. La Combe. 1260 Nyon. Tel: 022 361 3412.

Rue du lac 25 1400 Yverdon. Tel: 024 21 5443.

Grand-rue 22 1820 Montreux. Tel.021 963 6449.

Rue du temple 3 1700 Friburg. Tel. 037 22 8892.

Grand-rue 12 1110 Morges. Tel: 021 801 3308.

Piazza Cioccaro 12 6900 Lugano. Tel: 091 23 1874.

Rue de la Confederation 8 1204 Geneve.
Tel: 022 310 7320.

Steinenberg 25 4051 Basel. Tel: 061 281 6565.

Limmatquai 94 8001 Zürich. Tel: 01 261 8801,
Fax: 01 261 8929

Neugasse 46 9001 St-Gall. Tel: 071 23 2238

Rte de Lausanne 10, 1950 Sion. Tel: 027 22 1888

Pages 80-83. Antique colour prints, private collection courtesy of Heide.

Pages 84-89. Nano tattooing his wife Mihinoa at his studio in Moorea, Tiki village, French Polynesia.

Pages 90-99. Tavita is a tattooist, musician, fire-dancer and his wife Chloe has just given birth to a boy, 'TUPUNA', Tiki village.

Pages 100-101. Tamatarii, tattoos and facial designs by Tavita, Tiki village.

Pages 102-103. Teina Toromona, tattoos by Tavita, Tiki village.

Page 104. Tautira, Papeéte, French Polynesia.

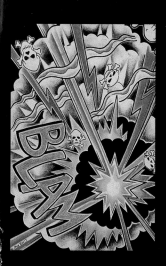

Page 105. Statue of Taaroa, the God of the Ocean, Moorea. Sculptors, Tutu.

Pages 106-107. Art by Marco Firinu, Genova, Italy.

Page 108. Clairey, film montage with art by Filip Leu.

Page 109. Clairey, film montage with art by Alex Binnie.

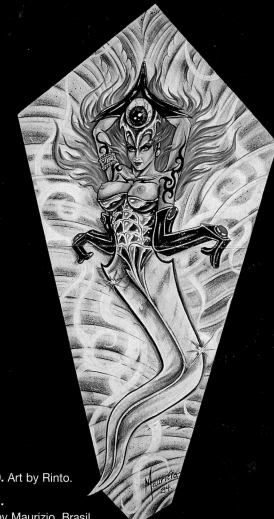

Page 110. Art by Rinto.

Page 111.
Top. Art by Maurizio, Brasil.
Bottom. Art by Alex Binnie.

Page 112. Body Electric Tattoo Studio, 7274 1/2 Melrose Ave, Los Angeles, Ca. 90036 USA. Tel: 213 954 0408.

Also Available: Signed Limited Editions by Chris W.

"Tattooed Women 2"

"Hans – A Head of His Time"

"Classic Skin Shows"

Available from:
(UK)
DTS, Tel: 01 630 655 875,
Fax: 01 630 655 015

(USA)
Spaulding & Rogers, Mfg. Inc., Tel: 518 768 2070,
Fax: 518 768 2044

(Deutschland)
Heide Heim, editor, TÄTOWIERMAGAZIN,
Ottenhöferstr. 8, 68239 Mannheim
Tel: 0621 4836194 Fax: 0621 4836195

TÄTOWIERMAGAZIN distributes Tattoo Calender 1996, books by Chris Wroblewski, Tim Coleman's video, Pigments of Imagination, and other high quality tattoo publications.

To ensure proper healing of your new tattoo, follow these instructions.

1. WAIT 24 HOURS, REMOVE BANDAGE. WASH TATTOO WITH COOL WATER & SOAP.

2. WITH CLEAN HANDS, APPLY A SMALL AMOUNT OF 'AFTER TATS', NEOSPORIN, ETC. 3 TIMES DAILY FOR 10 DAYS

3. DO NOT EXPOSE TATTOO TO SUN, SALT WATER, HOT TUBS OR SAUNAS FOR 14 DAYS. AFTER SHOWER PAT DRY.

4. DO NOT PICK OR SCRATCH TATTOO.

5. DO NOT LISTEN TO TATTOO 'EXPERTS' IN BARS OR ON THE STREETS FOR 1 MONTH!